MW00581600

AMERICAN
PSYCHOANALYTIC
ASSOCIATION

Contributors

Julia-Flore Alibert, MD, is a child psychiatrist and psychoanalyst member of Société psychanalytique de Paris, working in private practice in Paris and in an institute for deaf children.

Daniela Andronache, PhD, is a candidate at the Romanian Society of Psychoanalysis.

Giuseppina Antinucci is a fellow of the BPAS, where she teaches. She has a private practice in Milan and is on the editorial board of the *International Journal of Psychoanalysis*.

Lee Ascherman is an adjunct professor at the University of Alabama at Birmingham School of Medicine and is a training and supervising analyst and child supervising analyst at the Cincinnati Psychoanalytic Institute.

Stefania Baresic is an RP (qualifying) member of the College of Registered Psychotherapists of Ontario and the Canadian Association of Psychodynamic Therapists, and IARPP, as well as a graduate of the Centre for Training in Psychotherapy in Toronto.

Lesley Caldwell is a member of the British Psychoanalytic Association and honorary professor in the psychoanalysis unit at University College London.

Joseph A. Cancelmo, PsyD, FIPA, is past president, training/supervising analyst, and co-chair of the Gould Center at the Institute for Psychoanalytic Training and Research (IPTAR).

Bernard Chervet, MD, is a training/supervising analyst in the Paris Society, past president SPP, representative IPA Board, and director French Speaking Psychoanalysts Congress (CPLF).

Viviane Chetrit-Vatine, PhD, is a training/supervising analyst at the Israel Institute of Psychoanalysis and the Tel Aviv University Psychoanalytic Psychotherapy Program. Past president of the Israel Psychoanalytic Society, she has a private practice in Tel Aviv and Jerusalem. She is the author of *The Ethical Seduction of the Analytic Situation: The Feminine Maternal Origins of Responsibility for the Other* (Routledge, 2014).

Tiffany Chu is a medical student at USC Keck School of Medicine. She is interested in mental health and narrative.

William F. Cornell, MA, TSTA (P), maintains an independent private practice of psychotherapy and consultation in Pittsburgh, Pennsylvania, and is the editor of the Routledge book series Innovations in Transactional Analysis.

Carmen Cuenca Zavala, PhD, is a member of the Association of Psychoanalysis in Guadalajara, member of IPA, and member of the dissemination committee of the FEPAL Virtual Library of Psychoanalysis.

Ronald Davies, MA, is a candidate at the South African Psychoanalytical Association (SAPA), Cape Town.

Miriam DeRiso, PhD, has a private practice in Pittsburgh, Pennsylvania, and is affiliated with Keeping Our Work Alive: Relational Psychoanalytic Training Group.

Michael Diamond, PhD, is an honorary member of IPTAR, where he is on faculty, and is a steering committee member of the Gould Center. In 2019, Michael received the award of

Distinguished Member of the International Society for the Psychoanalytic Study of Organizations (ISPSO).

Simonetta Diena, MD, is a training and supervising analyst at the Societa Psychoanalitica Italiana (SPI) and the IPA. She lives and works in Milan.

Cristina Escudero, PhD, is a supervising psychoanalyst at the Madrid Psychoanalytical Association, has a master's in family psychotherapy, and holds an expertise in group dynamics.

Yehuda Fraenkel, MD, is a psychiatrist, psychoanalyst, member of the Israeli Psychoanalytic Society and IPA, and on the faculty in the Department of Family Medicine at the Hebrew University, Jerusalem.

Elizabeth Goren, PhD, is on the faculty of New York University's postdoctoral program in Psychotherapy & Psychoanalysis.

Joachim Kuchenhoff is a member of the IPA and of the Swiss and German psychoanalytic societies. He is editor-in-chief of the *Swiss Archives of Neurology, Psychiatry and Psychotherapy* and president of the supervisory board and visiting professor at International Psychoanalytic University, Berlin.

Dinah Mendes, PhD, is a member of IPTAR and a psychotherapist and psychoanalyst in private practice in NY.

Kate Muldowny is a child and adolescent therapist in private practice in Manhattan. She is the director of the IPTAR Child and Adolescent Psychotherapy Program.

Rosemarie Nassif is a candidate at the Lebanese Association for the Development of Psychoanalysis (ALDeP) (Association libanaise pour le développement de la psychanalyse www.aldep.org)

Marc Nemiroff, MD, is a member of the Washington Baltimore Center of Psychoanalysis and former chair of the Infant & Young Child certificate program at the Washington School of Psychiatry.

Justyna Pawłowska, MA, is a psychologist and psychoanalytical psychotherapist at Polish Psychoanalytical Society.

Gianpiero Petriglieri, MD, is an associate professor of organizational behavior at INSEAD.

Juan Pinetta is a member of Asociación Psicoanalítica, Argentina.

Adriana Prengler, FIPA, is a training analyst at NPSI (Northwestern Psychoanalytic Society and Institute), SPC (Caracas Psychoanalytic Society) and vice-president elect of the IPA.

Bartosz Puk, MD, is member of the IPA, GroupOne, and the Polish Psychoanalytical Society (PTPa), where he is president of the PTPa Revisory Commission.

Laura Ribeiro Ferreira, PhD, is a specialist in psychoanalysis from the Institute of Psychiatry from the Federal University of Rio de Janeiro (UFRJ), holds a master's degree in public health by ENSP/Fiocruz, and is a candidate of the Psychoanalytic Society of Rio de Janeiro, Brazil.

David Rosenfeld is a training analyst at the Buenos Aires Society, consulting professor of psychiatry at Buenos Aires University, and past vice president of the IPA.

Julia Roy-Stäblein is a psychologist and psychoanalyst in private practice who works at the Centre de psychanalyse et de Evelyne and Jean Kesternberg Psychoanalysis and Psychotherapy Center at the Mental Health Association of the 13th arrondissement of Paris (ASM 13).

Cosimo Schinaia, MD, is a training and supervising analyst of SPI and full member of IPA.

Gertraud Schlesinger-Kipp is a psychologist, psychoanalyst, and training analyst of the German Psychoanalytical Association (DPV, IPA), former president of DPV, former member of IPA Board, and member of COWAP and Migration and refugees committee.

Harvey Schwartz, MD, is a training and supervising psychoanalyst at the Psychoanalytic Association of New York (PANY) and at the Psychoanalytic Center of Philadelphia (PCOP). He is a Clinical Professor of Psychiatry at the Sidney Kimmel Medical College in Philadelphia. He currently serves as the Chair of the IPA in Health Committee.

Irina Sizikova, PhD, is a clinical psychologist at the children's and teenage narcological department of Clinical Hospital in Moscow, a member of the Moscow Group of Psychoanalysts, and a member of the IPA.

Alice Lowe Shaw, PhD, is a member of the Psychoanalytic Institute of Northern California (PINC) in San Francisco.

Drew Tillotson, PsyD, FIPA, is vice president of North American Psychoanalytic Confederation (NAPsaC), member of the IPA Psychoanalytic Education Committee, and past president of the Psychoanalytic Institute of Northern California (PINC).

Manuela Tosti, PsyD, lives in Bolzano, Italy, studied psychology at the Leopold Franzens Universität Innsbruck (Austria), works as a psychotherapist in private practice, and is currently being trained as a psychoanalyst at the Training Institute of Self Psychology and Relational Psychoanalysis (ISIPSé) in Milano.

Elizabeth Trawick, MD, is a psychoanalyst practicing in Birmingham, Alabama.

Brian Wu is a MD/PhD graduate from Keck School of Medicine of USC and is a current psychiatry resident at LAC+USC Medical Center.

Ümit Eren Yurtsever is a psychoanalyst at the Istanbul Psychoanalytical Training, Research and Development Association (Psike Istanbul).

Hattie Myers, PhD, FIPA, member of ApsaA and supervising/training analyst at the Institute for Psychoanalytic Training and Research (IPTAR).

Mafe Izaguirre is a New York–based Venezuelan artist, graphic designer, and educator. She leads the strategic design advisory firm, Simple 7 Lab, specializing in brand management. Contact us: mafe@simple7lab.com

Eduardo López is a Chilean graphic designer and educator with more than thirty-five years of professional experience in the editorial design field. Eduardo is a Senior Editorial Designer at Simple 7 Lab.

Poets

Kate Angus's work has appeared or is forthcoming in *Barrow Street, Indiana Review, Court Green, Gulf Coast, The Atlantic*'s online Object Lessons series, *The Washington Post*, and the Academy of American Poets' Poem-A-Day feature. She is the recipient of an A Room of Her Own Foundation Orlando award and an Elizabeth Kostova Foundation Sozopol Seminar fellowship, as well as residencies from the BAU Institute, the Betsy Hotel's Writer's Room and Interlochen Arts Academy (writer in residence). Angus is the author of *So Late to the Party* (Negative Capability Books) and the founding editor of Augury Books. Born and raised in Michigan, she currently lives in New York.

Nan Cohen is the author of two books of poetry, *Rope Bridge* and *Unfinished City*. The recipient of a Stegner Fellowship, a Rona Jaffe Writer's Award, and an NEA Literature Fellowship, she lives in Los Angeles and codirects the poetry programs of the Napa Valley Writers' Conference.

Eugene Mahon, MD, is a training and supervising psychoanalyst at Columbia Psychoanalytic Center for Training and Research. He has published three books—*A Psychoanalytic Odyssey, Rensal the Redbit*, and *Boneshop of the Heart*—and numerous articles on psychoanalysis. He practices in New York City.

Marc Alan Di Martino is a Pushcart-nominated poet and author of the collection *Unburial* (Kelsay Books, 2019). His work appears in *Rattle, Baltimore Review, Palette Poetry, Valparaiso Poetry Review, Rust + Moth, Matador Review, Innisfree Poetry Journal*, and many other journals and anthologies. New work is forthcoming in *Tinderbox, Free Inquiry*, and *First Things*. His second collection, *Still Life with City*, will be published by Pski's Porch in 2020. He lives in Italy.

Amy Miller's full-length poetry collection *The Trouble with New England Girls* won the Louis Award from Concrete Wolf Press. Her writing has appeared in *Barrow Street, Gulf Coast, Tupelo Quarterly, Willow Springs*, and *ZYZZYVA*. She lives in Ashland, Oregon, where she works for the Oregon Shakespeare Festival and is the poetry editor of the NPR listeners' guide Jefferson Journal.

Galit Hasan-Rokem is professor emerita of Hebrew literature and folklore research at the Hebrew University. In addition to many scholarly books and articles, she has published three poetry volumes in Hebrew and several poetry translations of major Swedish poets into Hebrew. She is also co-editor of *The Defiant Muse: Hebrew Feminist Poems from Antiquity to the Present* and cultural editor at the *Palestine-Israel Journal*.

Jeneva Stone is the author of *Monster*, a mixed genre collection. She has received fellowships from the MacDowell and Millay Colonies. Her poetry and essays have appeared in numerous literary journals, including *Waxwing, Scoundrel Time*, and *APR*, with work forthcoming in *New England Review*.

Jeffrey Thomson's most recent book is *Half/Life: New and Selected Poems* from Alice James Books. He is professor of creative writing at University of Maine, Farmington.

Artists

Enrique Enriquez is a New York-based Venezuelan poet. His work with the Marseilles Tarot breaks new ground intellectually and artistically.

Linda Louis, BA, MFA is an artist whose work has been handled by a number of New York City and Greater-Metro art galleries. Presently, as in the past, Ms. Louis has occupied positions on the boards of directors of art organizations. Ms. Louis is an art consultant, an art competition juror, and an art curator. Ms. Louis's artwork has been shown in the *New York Times* and other publications. She taught entrepreneurship, with an emphasis on art, at Hofstra University, worked as an art instructor for the YMCAs of New York and New Jersey, and has taught Asian children and adults for the YMCAs through an interpreter. She was honored by Nassau County, New York, as a "Groundbreaking Woman" for her body of work and her contribution to the field of art. Ms. Louis is also well known as an abstract land-sea-skyscape painter. One of her nine suites of work centered on the face, eighty-seven bas-relief sculptures called "Earthkins," inspired by the faces of children she encountered in her childhood due to her long involvement with challenged youngsters, won her special recognition by the National Endowment for the Arts as featured artist for their fiftieth anniversary. Her "Famly of Humans" series is the latest to receive special recognition.

Susan Luss (b. El Paso, TX) is an inter-disciplinary artist living in New York City, maintaining a studio in East Williamsburg, Brooklyn. Luss received her MFA from the School of Visual Arts, New York, and her BFA in Studio Arts Painting from Pratt Institute, Brooklyn. Luss has exhibited her work at various venues in the New York area and beyond, including Lowe Mill A&E in Huntsville, AL, the Museum of Art and Culture, New York, Chashama in Brooklyn, Brooklyn Waterfront Artist Coalition, the Knockdown Center, Brooklyn, and Sideshow Gallery in Brooklyn, the Hole in NYC, Haverstraw RiverArts in Haverstraw, NY, Garner Arts Center in Garner, NY, Westbeth Gallery and the Painting Center in NYC, among others. Luss has curated exhibitions at Pratt Institute, Westbeth Gallery, and Aaron Davis Hall, City College of New York. She serves as an advisory member of ArtShape Mammoth, a nonprofit organization with the mission to cultivate arts research, education, and dialogue by supporting the development of artists and connecting them with new communities. Luss's work is held in public and private collections including Pratt Institute, Brooklyn, and La Table des Artistes, France, among others.

Rafael Silveira is an internationally renowned Brazilian fine artist with a strong background in the graphic arts. Silveira graduated in fine arts at Federal University of Parana, Brazil, and received a degree in advertising from Centro Universitario Curitiba in 2002. His works have been exhibited in prominent Brazilian galleries and are included in numerous collections such as the Museum of Modern Art in Rio De Janeiro. Silveira is a three-time winner of the Max Feffer Design Award. The majority of his works consists of oil and acrylic paintings that mix a classical atmosphere with contemporary techniques and subjects, especially cartoon imagery.

On March 11, 2020, Tedros Adhanom Ghebreyesus,
the director-general of the World Health Organization
declared COVID-19 a pandemic and called for countries
to take urgent and aggressive action.

"Pandemic is not a word to use lightly or carelessly.
It is a word that, if misused, can cause unreasonable fear,
or unjustified acceptance that the fight is over, leading
to unnecessary suffering and death… We cannot say
this loudly enough, or clearly enough, or often enough:
all countries can still change the course of this pandemic."

On June 25, 2020, the director-general announced that
the number of infections were expected to reach ten million
next week and the number of deaths five hundred thousand.

**Editorial
6.20.1**
June 10, 2020
New York, NY, USA

Hattie Myers
hmyers@analytic-room.com

ROOM 6.20 | A Sketchbook for Analytic Action

Dear Reader,

Psychoanalysis, art, and poetry make visible and expand the boundaries of our psychic reality and so the world. But what happens when those boundaries fracture? When we are on top of each other and oceans apart? When days merge and space contracts? When inner and outer reality converge on a pixilated screen? Just this. We must create a new path forward.

For the last three and a half years, each issue of ROOM has been a snapshot of our struggle to make sense and give expression to our experiences. Launched only a few days before the pandemic hit the United States, we knew that ROOM 2.20 was the darkest, most foreboding issue we had ever released. What we didn't know was that it would mark the moment before everything changed—in our consulting rooms and in our cities. Standing still, ROOM 6.20 marks the first weeks of COVID-19. With over fifty contributors, this magazine is the most international and interdisciplinary issue we have published to date. Mingling souls, ROOM 6.20 is as intimate, authentic, and immediate as a letter. It cuts across time and space. It is non-linear. Start anywhere.

Hattie Myers
Editor in Chief

The poem I was going to write was smaller than this.
First it grew to the size of the room
until its flanks nudged the walls.

Shelter

And then to the size of a house.
Walking through it was like
being inside a soap bubble in a dream,
the outside distorted and wavering.

And now we are all living in it —
our weather, our element.
There is nothing left to tell except
that this is what it is like
to live inside a poem —

the slanting light before dusk, and grief
brushing your cheek like a wing.

Tiffany Chu
tiff.chuchu@gmail.com

With help from Brian Wu

Letters from
LOCKDOWN

Last week, I dug up a box of my parents' old letters. They were written before my parents were married, while my mom was still in Taiwan and an ocean away from my dad in the United States. A surprising number of the letters were in English; the writing is stilted, and it's clear that English is neither of my parents' first language, but the mundane recounting of their days felt somehow both endearing and sacred. Holding the tangible artifacts of my parents' courtship in my hands, I imagined for the first time the twentysomethings they were when they wrote those letters.

Handwriting letters is more a novelty than necessity now. It seems silly to write and send a letter when a text message will solicit a response within minutes. My daily musings don't merit the ink, paper, postage, and time required to carry the words across the country; the use of those resources deserves more deliberation and depth of thought.

But as we are often reminded, these are unprecedented times. This pandemic, for those of us ordered to stay at home, has redefined time and distance. There's a simultaneous contraction and expansion of the old conceptions of space. In the six weeks since I was suspended from my nonessential role, the separation between me and the rest of the world has become vast. My weekly trip to the grocery store ten minutes away is now the longest journey I make. The closest physical proximity I have with strangers is while navigating the canned foods aisle, all of us eyeing each other distrustfully over homemade masks, a careful shopping cart's distance apart.

Meanwhile, downtown LA's skyline is crisper and the hills beyond more immediate. The newfound flexibility in our schedules has shrunk the distance from far-flung loved ones. This is a time of reconnection—with each other and with ourselves. Things are clearer, and the distance between mailboxes seems more surmountable.

I've started exchanging letters and postcards with some of my oldest friends. Now, when there is no clear delineation between days, writing to others gives me reason to think about small daily events and assign them significance in the act of writing about them. It also forces me to write more thoroughly about the things that do happen as well as my reactions to them.

Writing as a path to self-knowledge harks back to Freud and Breuer's catharsis theory. Though the field of psychoanalysis has moved on, the fundamental work of uncovering previously unrealized causes of emotional reactions remains a cornerstone. In their work on writing out emotions as a way of processing and coping with trauma, Pennebaker and Beall (1986) refer to the cathartic method and note that writing about emotions surrounding significant events has beneficial long-term effects on both mental and physical health. Diana Chao, founder of mental health initiative Letters to Strangers, describes letter writing as a back-and-forth exploration similar to psychotherapy: "It helps transport our inner, nonlinear dialogue into a conversation." In this time of isolation, it's more important than ever to be aware of ourselves and to be having conversations in the ways available to us.

Whether letter writing is used as catharsis or as a chronicle of small daily events, the act of writing and sending letters is a physical expression of care. The arrival of a new note in the mail is something to look forward to and is a regular reminder to check in. And for some of my correspondents, it's been a chance to share the lockdown hobbies they've picked up. It's an extra-special touch to receive a letter written in calligraphy, or a postcard decorated with watercolor and collage. I hope, when lockdown restrictions begin to ease and we reemerge into normalcy, that we'll carry with us these new ways of connecting.

Pennebaker J.W., Beall S.K. "Confronting a Traumatic Event: Toward an understanding of inhibition and disease," *Journal of Abnormal Psychology* (1986).

6.20.4
March 21, 2020
Pittsburgh, Pennsylvania, USA

Miriam DeRiso
miriamderiso@gmail.com

Yesterday, my phone rang early in the morning. The voice on the other end of the line whispered, with strain, "I'm sorry. I came home for spring break, and I won't be returning to Pittsburgh for a while. I don't know what we can do. Is there anything we can do?"

I had only met her a few times. She had come with her boyfriend who held her hand as she described her family: the physical slaps, the strict rules about never leaving the house, and the humiliation that was served up anytime she mentioned wanting to see her friends. She cried, she shook as she told her story.

We agreed to meet via phone sessions at a specific time. She would try to get out to her sister's car, the only private space in the tiny house. She sounded relieved that we could stay connected.

Miriam DeRiso

6.20.5
March 9, 2020
Buenos Aires, Argentina

David Rosenfeld
rosenfeld236@gmail.com

ROOM 6.20 | A Sketchbook for Analytic *Action*

Dear all,
Here in Buenos Aires
Tango city

We are working
By telephone
And Skype
With patients

The country will be
Confined

I repeat
All the country will
Be
Confined

Nobody can go for a
Holiday

We must avoid
Movements of
People

We are in our homes
Isolated
In Quarantine
With
My family
Cleaning the house
Kitchen table, doors
3 times a day

Hotels
Are used
As hospitals
From today
The same
As happened in Germany

Kind regards,

David Rosenfeld

Photo by Andrea Leopardi

Kate Muldowney
kmuldowney6@gmail.com

I thought I'd share some thoughts I wrote earlier today. By way of explanation, I started my career as a young social worker at the outset of the AIDS crisis in the United States. These weeks have so reminded me of those early days of AIDS: the fear, terror, and confusion. After working in pediatric HIV in the Bronx for eight years, I was able to travel to visit schools and orphanages in East Africa numerous times. I witnessed firsthand the destruction that HIV wreaked in the lives of children. I share these thoughts not to minimize the terror and sadness of our current times, but to place our experience in context of the global experience of infection and the long suffering of children. I hope we can come together to provide support to each other and our young patients during these trying times.

Not True: Some things just aren't true. It's not the first time that vulnerable communities have lost their jobs, their children, their sense of safety to infectious disease. It's not true that old people have never died alone, lived in isolation from their loved ones due to disease. It's not true that communities haven't seen massive senseless deaths, funerals canceled, lonely, unattended dying hours, orphaned children, loss of precious healthcare workers, the decimation of financial systems. It's not true that communities of children haven't stayed home long days from school due to illness of adults. It's not true that children haven't felt the hunger and deprivation related to the illness and job loss of their parents. It's not true that children haven't spent countless never-to-be-recovered months and years of childhood fraught with boredom and lonely sadness because of disease.

Those are all stories we are telling ourselves to cover our collective amnesia of our great disinterest in the avatars of HIV, malaria, tuberculosis, and Ebola that have stalked the developing world every day, every school year, every fiscal year, with no end in sight; from whole nations in a kind of quarantine from ever having a "regular" life.

No three months' time off and then back to normal.

Remember: there was no urgency about getting treatment, no race for vaccines for these highly treatable diseases, no concern about entire countries that have no ventilators. No concern for countries whose best and brightest were siphoned off, headed to hospitals in Europe and America, leaving generations of suffering people with untreated disease. Stupid, preventable deaths of the young went unmourned and unacknowledged by the disinterested, indulged world. No alarm sounded for inadequate, unsafe hospitals, exposed healthcare workers, endangered grave diggers, and unpaid undertakers.

Don't forget: in the twenty-first century, Ebola patients in West Africa were treated in tents in the bush in one-hundred-degree heat by volunteer doctors. That was five years ago.

What is true: this is the first time the whole world, no exceptions, has felt the terror of infectious disease, the specter of an overwhelmed health system, the sadness and anger of children kept out of school, the rage and impotence that treatments are available but somehow inexplicably inaccessible.

It is true now that infectious disease has exacted its most democratic incursion—heads of state, basketball stars, Hollywood actors. This is the infectious disease that won't let us off the hook; it doesn't belong to gays, IV drug users, poor women in dusty, parched, forgotten areas of the world. It belongs to us, all of humanity. This virus is our introduction to the world.

Kate Muldowney

Julia-Flore Alibert
julia.alibert@wanadoo.fr

Dear All,

I would like to share with you my short experience doing video sessions with children from ages four to fifteen during this troubled period. I still work in my office, which is in a part of my home, so they can see me and the office on the video. Most of the children have chosen to continue the therapy. I tell the parents to let their child stay in a quiet room alone with the phone on video call. The children can then move with the phone...and the troubles begin! I can see their private universe; they show me their room, their bed, their toys, the pictures on the wall. They make me visit the entire apartment, their brothers' and sisters' rooms, even the parents' room—a direct primitive scene! The camera is always moving, so it is sometimes difficult for me to follow, but this is interesting because I can see the world as they want to show it to me, with their eyes. I see the world from their one-meter height and it changes my outlook. Suddenly everything seems very big to me: the furniture, the parents. I can better remember what it's like to be small, surrounded by things that seem giant, and maybe I can better reconnect with my infant parts and identify with them. Some of my patients draw on paper and show me their drawings. With one five-year-old child, we made up a fight with puppet and figurines, but this time it was my toys against his toys; a lot of aggressiveness emerged with this usually inhibited boy. With another child, I played mime games and dice games; with another, the hand game rock, paper, scissors; with another, we prepared a meal with a play "dinette" set by asking "What do you have at home?" and "What do I have in my office?" And then we shared a common meal. With another child, we played a hide-and-seek game, but it was difficult for me to find the child outside the screen. One child was in his kitchen and started to show me all the things he was forbidden to touch, touching the oven or bringing food out of the fridge, and I had to say, "No, stop!"

At the end of our time together, the children all want to continue the video session. Some ask me to show them their drawing folder that I keep in my office, and it was a relief for them to see that things stay in the same place. At first, the children seemed happy to stay at home, not go to school, and spend time with their parents, but it has only been four days, and now they are beginning to miss school friends and teachers. Some of them showed me their work from school, their notebooks, with a lot of emotion.

I will continue to work like this; for the moment, I don't know how long it will be possible to keep contact, but I think we can do a lot of things on video session with children that bring up interesting things, that we can maybe theorize after.

Julia-Flore Alibert

Photo by Stijn Te Strake

...I can now add a few comments because now I have had three more weeks of practice in Paris working with children with video. It is interesting and helpful (I hope) but very exhausting for the analyst because it asks for a lot of concentration. Sometimes there are technical problems with sounds or image, and it is discouraging. For the children, it can also be difficult to maintain the video contact. In my experience, video allows for the emergence of a lot of aggressivity in the sessions. The child can lock his analyst in his toy box or wherever he wants by moving the phone. The child can attack the analyst directly on the screen. Sometimes I have felt like a turtle turned over on its shell which can no longer move. Now on the third week of confinement, I observe that more and more fantasies and drawings of the virus are coming into the sessions with anxiety of death or with the themes of healing or hospitals.

Julia-Flore Alibert

I can share with you a beautiful moment from a session last week. A six-year-old little girl created a moving story of a big ball rolling in the street that fell on a magic clock. The magic clock didn't work anymore, everything was blocked; all the cars, all the people stopped—everything was blocked, and the big ball was sticky, and that got bigger and bigger. I asked the girl if we could do something to fight this ball, and she said, "No, we can't do anything. We tried a lot for a long time, but nothing worked." She was very discouraged at this time, and I too felt hopeless along with her. But I asked: "Are you sure we can't do anything?" And she remained silent for a moment. We were both very sad, filled with a feeling of hopelessness at this moment. And suddenly she said, "No I know what will happen! Blue fairies will work a lot to make a big catapult to get rid of the ball—a big, big, giant catapult. It will be long and hard, but the blue fairies will make it work! And after that, the magic clocks will work again." She made me feel very joyful and hopeful at this time, and I thanked her for that. The blue fairies made me think of all the nurses at the hospital who are actually working to heal people. I think during this session, even with the distance of video, this little girl was very connected with my own feeling of despair, and we were able to overcome it together in a therapeutic experience.

Julia-Flore Alibert

Photo by Chuttersnap

Adriana Prengler
lalipren@gmail.com

Dear all,

In the Seattle suburbs (where I live), people stay at home, as in most cities in the world, except for outings for groceries, to the pharmacy, and for walks or biking on trails. My state (Washington State) has not officially declared a lockdown yet, even though there are many infected and many fatalities, especially among the elderly.

As many others have described, I initially consulted with my patients about the possibility of continuing their treatments remotely, but since last week, I started working exclusively by Skype, phone, FaceTime, and Zoom, and now I have learned about doxy.com.

At the beginning of the session, I direct the camera toward my face to greet my patient, as I would do in their physical presence, and I show my face again at the end of the session. But during the session, with the patients who use the couch, I direct the camera toward the window, so the patient sees the sky that they always see through the window of my office when lying on my couch, so their view is the same as when they are in the office. This way, I try to minimize as much as possible the enormous distance that exists between a face-to-face session and a forcibly remote one.

With some patients, the material that emerges is attached to external reality, but with others, remote sessions are very similar to in-the-room sessions, and the external reality is facilitating the emergence of forgotten or repressed material that is linked to their past experiences, personal history, and traumatic events. This terrible crisis has brought not only the least healthy regressions as some have described (patients in their pajamas, etc.), but also regressions in the service of making the unconscious conscious, recalling details of traumatic situations in their history, of war, traumatic memories of previous times in oppressive governments, and different types of losses. Others, on the other hand, show their denial of the situation. And still others have responded with panic and hopelessness.

I consider it very important to differentiate between these three reactions:

Panic as an overreaction to a dangerous situation that precipitates erratic, impulsive behavior, the blaming of others, and the taking of extreme measures.

Denial that disconnects one from the reality of the situation and thereby exposes one to the virus, which is then spread to others.

Fear is an appropriate emotional reaction to a dangerous situation. It prepares us for fight or flight, or, in this circumstance, disposes us to take appropriate action in the face of the realistic danger.

Although this situation is terrible, we can also see positive aspects that I hope will be a consequence of what we are experiencing: the main one is that the whole world is now united in fighting a common enemy. There are no opposing interests in this, as there are in wars, where each side defends their own and attacks the enemy, or as there are in political situations, where the parties work for their own interests (at least at the beginning of the pandemia). Today, we are all united in a global way, and I hope that we will be able to learn from this situation and will be more aware of how to take care of this world that belongs to everyone. Hopefully, this situation will help us change some of the currently popular values more in the direction of joining humanity together, regardless of political positions or racial and social differences.

Thank you all for your valuable comments and articles, and for this opportunity to share, to support and protect each other! Let's keep working together!

With my warmest regards to all,

Adriana Prengler

Viviane Chetrit-Vatine
chetritvatineviviane@gmail.com

Dear all,

Since last Monday, I have been working by phone, going through my regular schedule. All my patients in analysis are very well and responding to this situation. My patients who were in face-to-face psychotherapy are discovering how speaking on the phone allows them freer expression. But obviously this mean of communication has to be good, first of all, for the analyst. Our ease or unease is immediately felt by our patients. Yes, we and our patients are all in the same situation, but we are in an asymmetric position, and our responsibility toward our patients—as well as toward the analytic process and the maintenance of the setting—is ours. We also must be connected with the particular personal benefits we are getting with these analytic encounters and how it may evoke a retraumatization on the part of patients who suffered the kind of narcissistic seduction of "too much love." Furthermore, the financial question remains, in the actual situation and still more in the middle of the analytic encounter. And once more, this question has to be asked: For the good of whom are these strange meetings? For the patient? For the analyst?

In Israel, we are in nearly full confinement since the beginning of the week. We have still not been invaded by one death but are invaded with the knowledge that it will come, as it has come to every other place. People here are quite disciplined as we are "used" to dealing with wars and great uncertainty. But...we are entering into the end of this week: Friday night. The synagogues are all closed. Everyone is in his or her place. No work. No cars.

Let's try to breathe!

Shabbat—a Sabbath of internal peace for everyone—and strength, courage, and determination for all those who struggle personally, as parents, as friends, or in hospitals with this virus. Embracing you...and Shabbat Shalom,

Viviane Chetrit-Vatine

Photo by Zekeriya Sen

Photo by Claudio Schwarz Purzlbaum

אהבה בימי מגפה / גלית חזן רוקם

רַק שְׁנֵינוּ בְּמַעֲלִית בֵּית חולִים

מַסֵּכָה מוּל מַסֵּכָה

יָדֵינוּ בִּכְפָפוֹת

לֵב אֶל לֵב נוֹגֵעַ

Love in Pandemic Times

Only we two in the hospital elevator

Mask to mask

Hands in latex gloves

Heart touches heart

Daniela Andronache
dani.andronache@gmail.com

Photo by Andrei Terecoasa

În România coronaviruşii au îmbolnăvit până acum mai puţin de trei sute de oameni (testaţi) şi până astăzi încă nu a murit nimeni. Oamenii par să înţeleagă recomandările de a ieşi doar pentru stricte necesităţi.

Şi totuşi, pe parcursul ultimelor două săptămâni, în şedinţele cu toţi pacienţii mei, am început să apreciez imens experienţa de viaţă pe care am acumulat-o în timpul adolescenţei pe vremea comunismului, când oamenii se luptau la propriu pentru o pungă cu făină în piaţă. Aveam 20 de ani în 1990, când lumea pe care o cunoşteam, cu toate lipsurile ei, a murit într-o noapte de Crăciun şi am găsit sub pom, în dimineaţa următoare, una complet nouă. Am sperat să fie una bună – s-a dovedit a fi una foarte dură. Cam la fel ca astăzi. Fabrici s-au închis şi oameni au fost concediaţi – la fel ca astăzi.

Mai târziu, aveam 39 de ani în 2009 când băncile internaţionale au oprit liniile de finanţare pentru afacerile locale din cauza crizei financiare globale. Multe firme au fost forţate să se închidă şi să aştepte vremuri mai bune. La fel ca astăzi.

Totuşi, în ciuda tuturor crizelor pe care le-am trăit, boala COVID-19 mi se pare cea mai înspăimântătoare. Poate din cauză că este atât de actuală. Se întâmplă acum, este pericolul imediat. Dar în acelaşi timp, pentru că nu văd sau nu simt în niciun alt fel acest inamic, nu îi pot testa realitatea, decât doar în imaginaţia mea, în imaginaţia mea liberă. În alte vremuri de criză am putut arăta cu degetul către cineva pe care mi-am proiectat toate fricile. Viruşii, însă, atacă fără ca oamenii să ştie măcar că sunt atacaţi. Este la fel de înfricoşător ca o invazie extraterestră. Frica mea de astăzi seamănă cu anxietatea pe care am resimţit-o când am văzut pentru prima dată Războiul Lumilor, filmul din 2005.

(https://www.youtube.com/watch?v=rYGWG2_PB_Q)

Presupun că aceasta este exact angoasa pe care o simte un copil când se naşte, când o lume moare şi una complet nouă şi foarte dură îi ia locul. De aceea vorbim astăzi despre o criză existenţială în fiecare dintre noi înşine şi în fiecare dintre pacienţii noştri.

Mulţumesc, Charlotte Stansfield din Australia, pentru cântecul de leagăn! :-) Să sperăm că ne vom simţi mai bine când va fi anunţat un tratament sau un vaccin. Ar fi semnul că un savant curajos va fi reuşit să-l vadă pe inamic şi să ni-l arate şi va fi găsit o armă cu care să luptăm împotriva lui, gata s-o împartă tuturor. Speranţa va fi mai bine susţinută atunci în fantasmele noastre.

Daniela Andronache

In Romania, the coronavirus has only sickened less than three hundred (tested) people so far, and nobody has died until today. Our population seems to understand pretty well the recommendations of going out only for strict necessities.

And yet, over these last couple of weeks, in the sessions with all my patients, I have begun to immensely appreciate the life experience I accumulated during my teenage years, during the communist time here, when people were actually fighting for a bag of flour in the market. I was twenty years old in 1990, when the world I knew, with all its scarcities, died over a Christmas night, and we found under the tree the next morning a completely new one. We hoped it would be good—it proved itself to be very tough. Sort of like today. Factories closed and people were fired—just like today. And then again, I was thirty-nine in 2009 when international banks stopped financing loans to local businesses due to the global financial crisis. Many businesses were forced to close down and wait for better times. Same as today.

However, in spite of all these crises I have experienced, COVID-19 seems to me the scariest. Maybe it is because it is current. It is happening now; it is the peril at hand. But at the same time, because I cannot see or sense in any other way this enemy, I cannot test its reality except for in my imagination—my free imagination. During other times of crisis, I could point out someone to project all my fears upon. The virus, however, attacks without people knowing they are under attack. It is as scary as an alien invasion. My fear today reminds me of the anxiety I felt when I first watched *War of the Worlds*, the 2005 movie.

(https://www.youtube.com/watch?v=rYGWG2_PB_Q)

I assume that this is the same anxiety a newborn could feel at birth, when one world dies and a completely new and very tough one comes into place. That is why we speak today about existential crises in ourselves and in our patients.

Hopefully, we will all feel better when a treatment or a vaccine is announced. It will mean some brave scientist would have succeeded in seeing the enemy and pointing it out and finding a weapon against it—and being ready to share that weapon with us. Hope will be better sustained then in our fantasies.

Daniela Andronache

To play the video, scan this code using your smartphone camera.

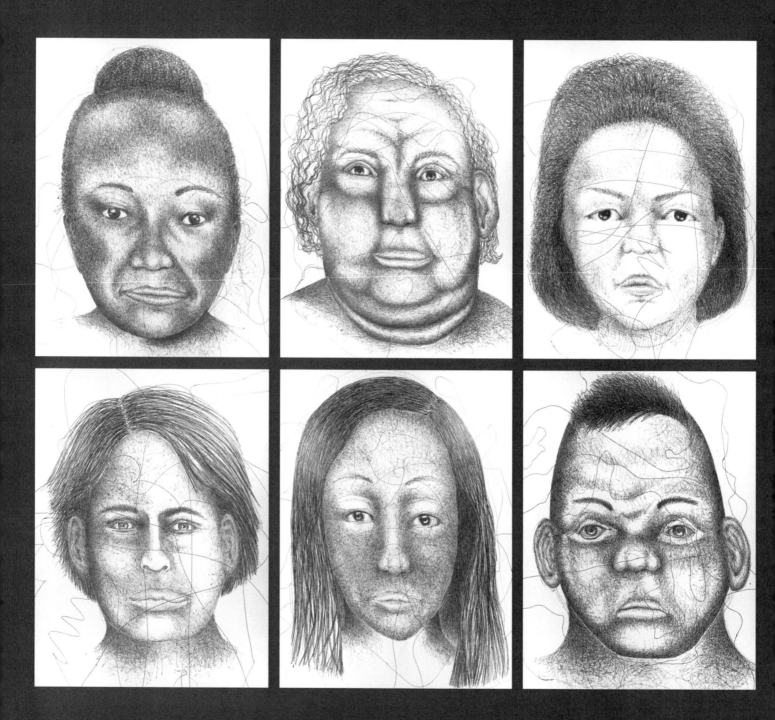

6.20.12
Ashland, Oregon, USA

Amy Miller
amymillerediting@gmail.com

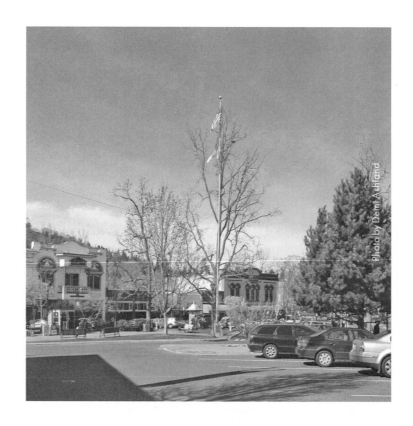

Photo by Demi Ashland

Working at Home, Day 5

One last trip to the office.
I grab the hard drive, folders, cheat sheets,
a stack of paper. Then I see

the plants—the three of them silent,
the big one flourishing, a gift
from a vendor years ago. I stand there
and think, Do I need to? Yes.

Three more trips to the car.
I lay their tendrils in the trunk.
Over and over, the same blasting thought:
What if they die? No, reader—
I mean the people who water them.

Dear colleagues and friends,

Photo by Nick Hillier

It is difficult here in San Francisco. We are officially in "shelter in place" mode, encouraged to remain at home. We expect our situation to be similar to what Italy has gone through. We're told the onslaught is a matter of time, not if, but when.

I am at home, conducting phone and camera sessions only. This frame requires a lot from both sides of the electronic chair/couch/computer/home/kitchen/dining room/playroom. Betty Joseph meant something quite different in her idea of "the total situation," but this is indeed a very 2020 total situation. Transference is only one part; there are many objects—dangerous, loving, dead, overstimulated, terrified.

In Bion's version of "catastrophic change," the process of relinquishing old object ties, the terror and survival of that, of coming alive, is internal. Yet I keep thinking about it. It seems very apt at this moment. Now, all is new, hour by hour, literally. The old must be relinquished in order to take in the reality of calamity, but the terror of surviving it is not only psychic at this point. It is bodily, a literal danger. A catastrophe of being forced to bend, of contending with a body that won't be ignored, of being forced to contend with each other as vectors of disease.

Today was day two here of "sheltering in place." Yesterday, day one, I struggled with sessions, restless, annoyed, sleepy; coffee tasted stale. Today, something shifted. At moments, in both phone and camera sessions, it was like meeting a whole new patient, a different version. I worked to open my mind, to dilate the frame. I kept turning to analytic intention as a mooring line. I started having reveries of holding sessions on the street, in a café, in a meadow, on the moon.

As the day went on, the work became freeing. Something powerful was occurring in the disruption of asymmetry—the fact that we were facing the same catastrophe evoked very playful, loving, surprisingly erotic moments. All amidst a tsunami of terror and disease moving towards us. It was a paradoxical soup of pain and pleasure, of love, great disappointment, impatience, crawling out of and into our skin.

The frame has to shatter and reconsolidate right now, from my little home office, in a corner of San Francisco. If it can't bend, I can't help or think. If I can't help or think, I will be forced to disappear in Netflix or googling factoids of terror.

So here's to the resilience of our minds. We can do analytic work from a lily pad, a flatbed truck, a dance hall, or billiard room. At least I am counting on that.

Warm solidarity from a heavily endangered, beautiful city by the bay,

Drew Tillotson

6.20.15
March 17, 2020
Lombardy, Italy

Pina Antinucci
Pina.antinucci@gmail.com

Hello, everyone, I am writing from Lombardy, and the picture I have is of frightened young people who are impatient to get rid of the obstacles to their self-created lives, because they are afraid of becoming helpless vis-à-vis fears and anxieties that cannot be contained.

I am aware of the sudden takeover of an uncanny stranger that has come to dispossess every one of our familiar routines and objects, to inhabit our external and internal world, including our dream space. This is a psychotic functioning that is partially silenced by obsessive practices like hand washing. The young, who often present this mode of functioning, are terrified of a psychotic destructuring; hence, they disavow their fears, evacuating them into us. Our containing capacity is inevitably diminished by our fear, distress, helplessness, and the sheer exhaustion of daily tasks, like shopping, for instance. The queues outside supermarkets now elicit in me "supermarket anxiety." Nothing is simple or reliable or can be taken for granted. It is a major shock.

Keep well, everyone,

Pina Antinucci

6.20.16
March 17, 2020
Krakow, Poland

Bartosz Puk
bpuk@icloud.com

ROOM 6.20 | A Sketchbook for Analytic *Action*

Hello friends,

It's so good to be able to communicate with you on the current difficulties and all the matters concerned with COVID-19.

I have been working in my consulting room in Kraków, Poland, for the last week and plan to continue with my patients by telephone or online. I do my best to consider this an opportunity to become closer to my patients.

I think we both come into contact with something through the "contact barrier" or thanks to the contact barrier and the virus.

I feel I have been able to construct with the patients who decided to continue (because not all of them have decided to continue in remote analysis) a "laboratory" for the "vaccine against the virus" to help develop our mental immune system. And as we know, constructing a laboratory for the vaccine, we need the virus and we need a specific setting which keeps us safe. All this work is very lively because of the idea of being possibly exposed and infected by the patient, who may have contact with someone. Or me infecting the patient because of my being infected with such a virus by someone "out there."

So this is all there, and the patient may have been infected by some foreign body or a bad object, but I may have been the same.

But come to think of it, I may have been infected by my supervisor who, by chance, is an analyst living in Milan. This "infection" may be in fact a healing possibility—that we get infected by functional thoughts and experiences of our supervisors who have undergone this wave of mutilation.

So I feel lucky to be able to discuss these issues with someone living in a very difficult situation—just like with this group here!

As I worked with my patients this week, my thoughts went to how they may be able to "infect" us with something, but maybe they can also bring in something vital, something truly emotional. It's just like the children—now we know through scientific findings and statistical analysis that children go through this disease relatively unharmed, and obviously this does lead to them being negligent (and having to deal with all those aggressive feelings) toward the elderly, their parents, and grandparents. But they have to cope with this, and also they apparently have a natural resistance and immune system against the virus. A system which is yet untouched by anti-inflammatory drugs, which we know also are not beneficial in this viral infection as they lower one's own immunity response. So the children, just like our patients, may be someone to turn to look for an answer about how to build our immune system.

Photo by Mateus Campos Felipe

And once I got this thought, of working together with the patients on "the vaccine" and on "the treatment," it opened up new areas for us. So at this moment, I try to look at the psychoanalytic field as a space where we can come close to something which is the unknown and using Bion's notion of the "negative capability" to withstand this and try to change things.

I will add that initially, when the virus was approaching my area, I found myself stuck between two possibilities. One was the rationalizing, the manic defense: "Oh, this does not concern me…oh, this is just another flu."

And on the other side was the panic of the apocalyptic scene, with perhaps even hysterical acting: "My God, we have to disinfect everything."

But I thought that this is just the defense against the unknown. We do not know and we have no certainty. How long it will take? How will it affect me? When will the "curve flatten?"

A lot has been said that this disease brings about the fear of death and fear of dying. But I think that perhaps, along with this, maybe what we are dealing with is a fear that we are not living. Now.

In fact, that we have been stuck behind some rational, fixed decisions, some consumerism, capitalism, and a half construct, and certain ideals, such as the setting, which simply crumble.

So I feel if we get through this crisis, experience it emotionally in our everyday practice, we may be able to liven things up and even change the way we work analytically. Perhaps nothing will be the same anymore.

Stay safe and well,

Bartosz Puk

P.S. I will just add—technically all this means I commute between my home and my consulting room (as we are in lockdown and I don't go anywhere else unless absolutely necessary) and I work with my patients by telephone or Skype. And this is not easy; I imagine myself trying to stay here in my consulting room during the hours that I see my patients. Nearly all of them have accepted the possibility of working in this manner, and I hope it's not necessary to close the consulting room and look for a consulting room space in my home.

Another technical issue that appeared is connected with the fact that if we can speak on the phone, there are apparently no boundaries. This, I feel, has to be considered: that we have to be respectful of a possibility and difficulty for the patient to find their private space on the side.

Ciesze się na tą możliwość komunikowania się z Wami na temat aktualnych trudności i wszystkich spraw związanych z COVID-19.

Od tygodnia pracuję zdalnie w moim gabinecie w Krakowie i planuję kontynuować taką pracę z pacjentami przez telefon lub online. Staram się traktować to jako okazję do zbliżenia się z nimi. Myślę, że razem stykamy się z czymś przez "barierę kontaktu" lub dzięki barierze kontaktowej i wirusowi.

Czuję, że udało mi się zbudować z tymi, którzy zdecydowali się kontynuować (nie wszyscy z nich zdecydowali się na zdalną analizę) swoiste "laboratorium" pracujące nad "szczepionką przeciwko wirusowi". Takiej która pomoże w rozwoju naszego psychicznego systemu odpornościowego. A jak wiemy, konstruując laboratorium dla szczepionki potrzebujemy wirusa i potrzebujemy specyficznej ramy, która zapewni nam bezpieczeństwo. Cała ta praca jest bardzo żywa z powodu fantazji o ewentualnym narażeniu i zakażeniu przez pacjenta, który może mieć z kimś kontakt. Lub że ja mogę być kimś zarażającym pacjenta z powodu bycia samemu zainfekowanym takim wirusem przez kogoś "bliskiego, gdzieś tam".

Więc to zarówno pacjent mógł zostać zainfekowany przez jakieś ciało obce lub zły obiekt, jak i to mogłem być ja...np. jeśli nie miałem wystarczającej analizy.

Ale pomyślcie też o tym, że mogłem zostać "zainfekowany" przez mojego superwizora, który przez przypadek jest analitykiem mieszkającym w Mediolanie. Ta "infekcja" może być w rzeczywistości uzdrawiającą możliwością - taką, w której zostaniemy zainfekowani przez funkcjonalne myśli i doświadczenia naszych superwizorów. Tych, którzy już przeszli tę falę zakażeń.

Czuję się więc szczęśliwy, że mogę omówić te kwestie z kimś żyjącym w bardzo trudnej sytuacji. Tak jak z naszą grupą tutaj!

W tym tygodniu, kiedy pracowałem z moimi pacjentami, myślałem o tym, jak mogą nas czymś "zarazić", ale może mogą też wnieść coś istotnego do analizy. Coś naprawdę emocjonalnego.

To tak jak z dziećmi - teraz znamy wyniki badań naukowych i mamy analizy statystyczne, z których wiemy że dzieci przechodzą tę chorobę stosunkowo nietknięte i oczywiście prowadzi to do tego że są one same z innymi (i muszą radzić sobie z tymi wszystkimi agresywnymi uczuciami) wobec osób starszych, wobec swoich rodziców i dziadków. Ale nie tylko muszą sobie z tym jakoś poradzić, bo także mają najwyraźniej naturalną odporność i układ odpornościowy na wirusa. System, który jest jeszcze nietknięty przez leki przeciwzapalne - które, jak wiemy, również nie są korzystne w tej infekcji wirusowej, ponieważ obniżają one własną odpowiedź immunologiczną. Tak więc dzieci, podobnie jak nasi pacjenci, mogą być kimś, kto może pomóc nam w poszukiwaniu odpowiedzi na pytanie, jak zbudować nasz system odpornościowy?

A kiedy pomyślałem o wspólnej pracy z pacjentami nad "szczepionką" i "leczeniem", otworzyło to dla nas nowe obszary.

W tym momencie staram się więc spojrzeć na pole psychoanalityczne jako na przestrzeń, w której możemy zbliżyć się do czegoś, co jest nieznane i użyć pojęcia "negatywnej zdolności" Biona, aby to wytrzymać i spróbować coś zmienić.

Dodam, że początkowo, gdy wirus zbliżał się do mojego rejonu, utknąłem pomiędzy dwoma możliwościami. Jedną z nich była racjonalizacja i maniakalna obrona "Oh, to mnie nie dotyczy... oh, to tylko kolejna grypa...".

A po drugiej stronie była panika sceny apokaliptycznej, z może nawet histerycznym aktorstwem "mój Boże, musimy wszystko zdezynfekować..."

Ale pomyślałem, że to tylko obrona przed nieznanym. Nie wiemy i nie mamy żadnej pewności. Jak długo to potrwa? Jak to wpłynie na mnie? Kiedy "krzywa spłaszczy się"?

Dużo się mówi, że ta choroba wywołuje strach przed śmiercią i strach przed umieraniem. Ale myślę, że być może to z czym mamy do czynienia, to strach, że już nie żyjemy. Teraz.

W rzeczywistości utknęliśmy za jakimiś racjonalnymi stałymi decyzjami, jakimś konsumpcjonizmem, kapitalizmem i pół wydolną konstrukcją oraz pewnymi ideałami, takimi jak sceneria, która się po prostu teraz naocznie rozpada.

Tak więc czuję, że jeśli przejdziemy przez ten kryzys, doświadczymy go emocjonalnie w naszej codziennej praktyce, być może uda nam się ożywić także sposób, w jaki pracujemy analitycznie i być może nic już nie będzie takie samo.

Bądźcie bezpieczni i zdrowi.

Ps. Dodam tylko - technicznie wszystko to oznacza tyle, że dojeżdżam do pracy autem, poruszam się między domem a gabinetem (ponieważ jesteśmy w zamknięciu w Polsce, nie jadę nigdzie indziej, chyba że jest to absolutnie konieczne) i pracuję z moimi pacjentami przez telefon lub Skype'a. I nie jest to łatwe - wyobrażam sobie, że staram się przebywać w moim gabinecie w godzinach, kiedy widzę moich pacjentów. Prawie wszyscy zaakceptowali możliwość pracy w ten sposób i mam nadzieję, że nie będzie konieczne zamykanie gabinetu i szukanie przestrzeni gabinetu w moim domu.

Kolejną techniczną kwestią, która się pojawiła, jest fakt, że jeśli możemy rozmawiać przez telefon to kontakt ten nie ma żadnych granic. W moim odczuciu należy wziąć pod uwagę, że musimy szanować możliwość jaką mamy i utrudnienia jakie to wnosi dla pacjenta, aby móc spotkać go.

6.20.17
March 22, 2020
Istanbul, Turkey

Ümit Eren Yurtsever
yurtseverumiteren@gmail.com

Dear David and all,

During the past five days of analysis, I can say that the patients have lost the line between fantasy and reality. They no longer can tell the difference. They have lost the concept of interior and exterior. They say they are living in a home where everything is intertwined. Most of them have stopped bringing dreams. The patients also feel guilty that I am alone in the therapy room. The most talked-about topics were me, the couch, the room's loss, and the mourning period, as they are no longer in it. As we continued with analysis online, the patients were all very excited once we connected through that medium. It was as if they had invited me into their homes; they described the room in detail and the most interesting thing was that while describing their room, they always mentioned their childhood toys and memories.

Ümit Eren Yurtsever

Thank you, thank you, thank you all.
These emails are so helpful. Let me just add a few words.

Some of my experience:

The pandemic is terrifying, and I often dissociate intentionally from the danger. It is exhausting to be constantly, unchangingly aware that there is an enemy out there; it is really there. It is invisible. It could kill me and the people I love.

Some days, I am on Zoom until my eyes can't see and my head feels caught between two cymbals, like in an old, from-childhood cartoon. (A bit of regression there.)

Trying to transmit empathy through a screen saps my energy, fortunately after the clinical fact. I certainly am tired of sitting at the same desk in the same stiff chair endlessly, or at least it seems that long. I am sad that seeing my people tires me; it didn't use to. I am tired of the artificiality of Zoom. We have to talk over each other until one of us is loud enough to grab the attention of the capricious yellow border, so it's my turn to talk. And the other person has to do the same. This situation, through no one's fault, creates a (albeit benignly intended) struggle between two people for airtime. Zoom is far better than nothing, but it never will be two people in the same room. And I miss the real people, the two of us. The saddest aspect of this is that we cannot share a laugh; only one person can be heard laughing at once. Part of my post-session exhaustion is grief. Day after day of "What is missing?" rather than gratitude for what is there, takes so much energy. And whoever said that mourning was easy?

To a certain extent, I've found a way to mitigate the Zoom distance, at least for some people. I am using the phone more, often at the request of the other person, sometimes at my own request, with permission. The phone focuses my attention on a single modality. There is no distraction from a flattened visual, or a freeze, or a funky mic, or a disrupted connection. (It's also distracting to see my face on the screen when I am trying to focus intently on the other. I listen more closely to shifts in breath, lengths of pauses, the tiny telling of a slight shift in tone of voice. Some people are more self-revealing over the phone. My best bet is that the lack of a visually artificial other intensifies the immediacy of the phone. Language is more spontaneous on the phone. It's a curious phenomenon.

It is also a comfort.

Marc Nemiroff

Photo by Brian Patrick Tagalog

Photo by Kadir Celep

"I spoke to an old therapist friend and finally understand why everyone's so exhausted after video calls. It's the plausible deniability of each other's absence. Our minds are tricked into the idea of being together when our bodies feel we're not. Dissonance is exhausting. It's easier being in each other's presence, or each other's absence, than in the constant presence of each other's absence. Our bodies process so much context, so much information in encounters, that meeting on video is being a weird kind of blindfolded. We sense too little and can't imagine enough. That double deprivation requires a lot of effort."

Gianpiero Petriglieri

6.20.20

Milan, Italy
Kassel, Germany
London, England
Warsaw, Poland

Simonetta Diena www.simonettadiena.it
Gertraud Schlesinger-Kipp gertraud.schlesinger-kipp@dpv-mail.de
Lesley Caldwell caldwell.lesley4@gmail.com
Justyna Pawlowska justyna.pawlowska@gmail.com

Dear friends, dear all. I'm from Milan. I've been living in isolation since the end of February. Now, it's almost a month. I'm seeing patients through Skype—all of them, including the one previously on the couch. No direct contact. They pay through the internet as well. Patients are now tired. Some of them are afraid to lose their jobs. Some have already lost them. They do not see the end of this nightmare. Children stopped going to school, and again, they have stopped since the last week of February. They cannot go out and play in the parks or in the public gardens; it's forbidden.

This is (isolamento) isolation, which means: the isolation of those sick necessary to prevent the spread of the virus. But we are not sick; it is a necessary action to prevent the spread of coronavirus in the population. Outside our windows and terraces, the sun is brilliant and lovely, but we cannot go out. We slip out covered with our masks and wearing our gloves, avoiding even eye contact with people we meet because we are afraid. We go out in a rush, to get the bread and the milk. We are ugly. Hairdressers are closed; beauticians are closed. We do not care about our dresses; we, from Milan, the fashion capital! It doesn't matter now because we do not see anyone. Our sons and daughters are living in their homes away from us because we, or they, could be contagious. We are as tired as our patients are; afraid of a global recession, to lose money and to lose our beloved ones. The very old are dying alone in the hospitals. We cannot see our old mothers or old fathers. We leave their shopping outside their apartments, and we speak with them many times on the phone.

We also speak with our sons and daughters, but we are working, as they are working. They call it "smart working," that is, from home. They're at home with their children, our grandchildren, whom we cannot see for the reasons I said above. Again, we spend long hours at the computer or at the phone. We call our friends, our relatives. We exchange jokes all the time. Nothing will be ever the same—we all know. We are not afraid to die or to get the virus, not more than other illness. But we want this to stop. We want our lives back; we miss the grass of this wonderful springtime, the beauty of the flowers of our countryside. We miss going out in the evening, going to La Scala or other concert halls, again closed since February. We miss the movies we loved seeing with friends at night—after many hours spent with patients, we'd go to see the last movie and then spend some time at a restaurant together. Or we invited our friend to our home, cooked for them, spent the evening talking and laughing. Some of them are in the hospitals. Some are struggling to remain alive with terrible pneumonia. Some are struggling to keep them alive, risking their own lives.

We are blessed with our excellent public health system; we are blessed with our doctors. We are doctors as well, and we left the hospital a short time ago, before the catastrophe. I don't know if you can understand the many pages of obituaries in the newspaper or the anxiety with which we wait for the 6:00 p.m. announcement from the Public Health Department, with the last list of new cases and deaths. We had booked holidays, conferences, meetings, congresses. They are canceled, one after another. Our gym is closed; our swimming pool is closed. The ski resorts are closed. This is isolation. It is like a war against some strange enemy which we do not see. Please, give us our lives back. I'm tired of listening to people crying because someone has died. It's my job, and I've done it pretty well for so many years. But I want my life back, and I don't want to lose my dear ones. Sorry for this long and useless cry. In five minutes, I'll start Skype again.

This is normal now.

Simonetta Diena

Dear Simonetta and all,

My second home is near Milano, and my whole body yearns to see the blossoming of the camellias and the white peaks of mountains behind. We in Germany are one week in isolation and it seems so long already, and there is still a phase of great solidarity, but if it goes longer, I can imagine we feel like you describe. You are beautiful, not ugly, because your heart is still open for your patients and loved ones.

I can work with my patients online or on the phone but not with the refugees, whom I see every week. We have to practice "psychotherapy with three" (translator), and it seems not possible on the phone. And as Ronald describes for South Africa, the poor ones cannot not be reached and cannot be isolated as we can. The virus, is a big leveler, someone said; yes, the virus is the same for everyone, but the social and psychic consequences are not the same. See at the EU borders (Greek-Turkish and Greek islands, Morocco), where some European countries still want to help and bring some of the refugees into our countries, especially the unaccompanied children. This is finito now; the borders are closed now; because of the virus, military forces fight them back! We don't need open racists and fascists now to do this.

Gertraud Schlesinger-Kipp

Thank you to all for the list itself and for the range of issues you all raise of continuing relevance to us all.

But especially thanks to you, Simonetta, for this cry from the heart about the reality of isolation for you, and now/soon us, as human beings and as analysts and the difficult and delicate emotional and psychical realities each creates for all of us.

Your message is anything but a useless cry; it represents the foundations of our life and work and why we do what we do.

We in London are just beginning this new reality we share with our patients and our colleagues, our families and friends, and your words carry such a resonance, I think for us all, but certainly for me.

Thank you.

Lesley Caldwell

Dear Simonetta and all,

We will have our lives back—not tomorrow, not in a month, but eventually we will. It may be a different form of our lives; nothing will ever be the same. Here in Poland, we have just started isolation. We work online or on the phone, trying to contain out patients' fears as well as ours and those of our children, as all of you do. I was in Milan in October 2018, and it is so sad to think about it now.

Thank you for sharing your thoughts.

Justyna Pawlowska

Photo by Monique Kraan

Impossible Bottle

Now that the jet stream of tourism has been stanched
like blood from a wound, history's monuments

lie quiet as a postcard on a desk:
Coliseum-as-cow-pasture, its ivory crown

grandstanding between those horse-drawn wagons
and shepherdesses dazed in a wood of columns

of Pinelli's vedute romane. Today, the selfies
self-medicate. Echo of lion's roar and martyr's cry

are all you can make out against this riddle of sky.
The future is a phone call that won't quite go through.

"Operator, is anyone there?" you blurt, but reception
is lousy, the earpiece hollow. You never get voice, presence,

Ich und Du. I and thou. Just I, one meter away from every
other I. Safety in distance. Danger in numbers. Chalk up

the days since life seemed normal. Calendar etched black with Xs.
Thank G-d, crank god, shipwrecked among stars, all of us afloat

in the same impossible bottle. Toss us a link to the future
& quick. It's crowded and our world is going under.

6.20.22
March 18, 2020
Paris, France

Bernard Chervet
bernard@chervet.fr

Translation by Laura Kleinerman

Dear all,
Paris is empty, very empty.

Very strange. But it is even possible to feel a beauty in this emptiness!
I have never seen Paris this way and in this state.
Since Tuesday, we have lived in a complete confinement, "lockdown."
We have to stay inside our houses, without permission to go out.
We need a certificate to go out and buy our food.

Since Wednesday, the police have issued fines if you do not have this certificate.
Many people have gone to the country, hoping for less virus.
There is a lot of medical theories, good and bad knowledge, fake news, etc.
Governments change knowledge and information every day.
Fortunately, some of us are doctors and have friends who work in research laboratories.

But discoveries change daily.

We all live in great uncertainty.

All precautions (washing hands twenty times a day, etc.) and guidelines are only useful for spreading the number of patients over a longer period of time; that doesn't stop you from getting sick; there is no healing yet.

You know too that 50 percent of the people who have these complications are less fifty years old.

As of last week, it was necessary to reorganize the scheduling of sessions. It is not easy for some patients to find a quiet space favorable to the regression of free association.

At first, the traumatic neurosis is triggered—and we need more time, latent time, to re-find the logics of the "après-coup" (or the deferred effect). For the moment, everything we are doing is inscribed in the logic of the first traumatic time.

The elusive viral disease is a great source of threat and negative irrational transference. The belief in the power of super-mother super-father is broken; the demand that the government, the doctors and scientists, and psychoanalysis offer all-powerful solutions comes with great anger and sadness and reproaches about the abandonment, the distress.

Fortunately, it is possible to work on the psychic implications, so the interest of the analytic work is preserved.

Many things could be developed about the gap between representations and perceptions, and about the variations of this gap in the current situation for the patient and for the analyst.

But at the moment, in France, the theoretical reflections on remote analysis are not the main subject. Maybe because the disease started several weeks ago.

Especially because the number of deaths increases every day in Italy-Spain-Germany-France at high speed (twice as much every day).

The number of deaths has reached the peak of the curve since yesterday, but not the top of the peak!

In Italy yesterday, more than 400 died during one day—each day. And it will continue during a week or two, maybe more!

So, we cannot have a debate on remote analysis in this context. Remote analysis is imposed on us.

Everyone is concerned with their health and that of those close to them. And the logics of "traumatic neurosis" dominate. At the moment, all my thoughts about remote analysis are based on the number of deaths, which is increasing each day.

Jean Cocteau found the words: "Mirrors are the doors through which death comes and goes." (The Wedding Party on the Eiffel Tower) For us, it's by phone and sound that threat and dread come and go, come back and return; and sometimes the issue of our own disappearance is disguised in other clinical forms. Libidinal co-excitement and masochism of the renunciation linked to the lack of perception when perception is reduced to sound only, are the ways by which thought can be reborn, by which the infantile can re-find its place. Only then this new situation will be able to be thought "après coup."

Hoping for all of our health.
Take care and stay safe,

Bernard Chervet

Fortunately, we have some tools to work with in the new context of remote sessions. Many psychoanalysts and patients have agreed to adapt their sessions to this new protocol, which retains the audio and video channels for face-to-face treatments.

Fortunately, the traumatic tonality which is evoked by the horror of the current situation does not force all our patients to remain in traumatic neurosis, even if this is the background of all that happens during the sessions.

Of course, many generic memories arise during the sessions and are accentuated due to the lack of the usual conditions—generic memories of illnesses, childhood infectious diseases, school breakups, confinement due to contagion, and the lack of teachers and classmates; memories of staying at home, close to the mother and other family members; etc.

Many specific memories are also evoked about traumatic illnesses and other traumatic experiences and mourning that they had to endure. And also memories pertaining to the specific relationships that each one lived with their family, in relationship to the disease, to the doctors, to the drugs, and the many theories about the body; the many means that families use to seek care and achieve healing; theories on the omnipotence of the mother who nurses and cares, and its opposite, the imago of the fatal mother who gives sickness to her children; and all the theories and fantasies about contamination and contagion, etc.

I just want to emphasize a point about our internal "frame" and the differences and gaps between the current situation and the previous one, that of the couch-armchair.

The "game" or play between representations and perceptions changes both for the analysand and for the analyst when the exchange is reduced to the single sound path and when what is missing becomes all the more important.

The analysand imagines his analyst in his usual, familiar office. He uses his representations; he is deprived of perceptions. Sometimes the representations become frightening hallucinations; then, the analyst becomes present at home; the patient prefers not to have phone sessions.

The analyst can imagine his patient physically absent but without any familiar stable representation. His listening and his thinking are deprived of the stabilized sensory presence of his patients in his office.

We will have to think little by little about all these concrete aspects, these gaps and changes, these new deprivations in order to be able to improve the theories of face-to-face and distance sessions.

Be careful and stay safe; above all, do not give in to the temptations of leaving the confinement too early.

Bernard Chervet

IPA's On and Off the Couch
Episode 48:
Current Pandemic Trauma in Relation
to Childhood Trauma
with Bernard Chervet, MD

*To listen to this podcast scan this code
with your smartphone camera*
http://www.analytic-room.com/letters/
letter-from-paris-bernard-chervet/

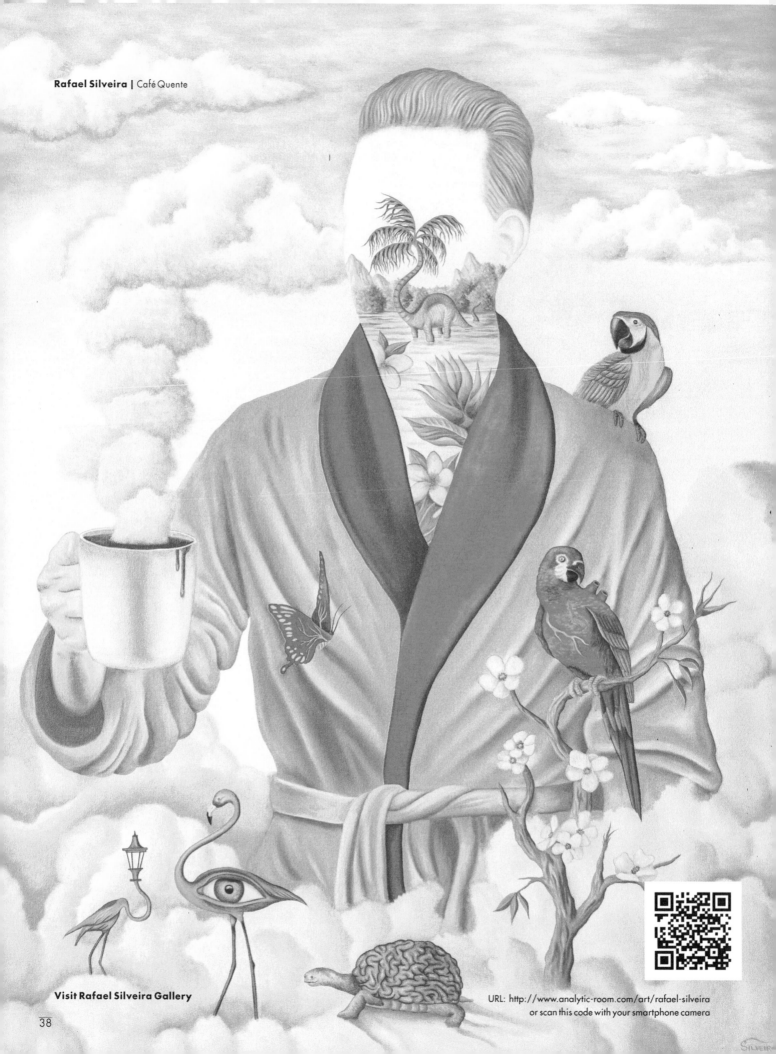

Rafael Silveira | Café Quente

Visit Rafael Silveira Gallery

URL: http://www.analytic-room.com/art/rafael-silveira
or scan this code with your smartphone camera

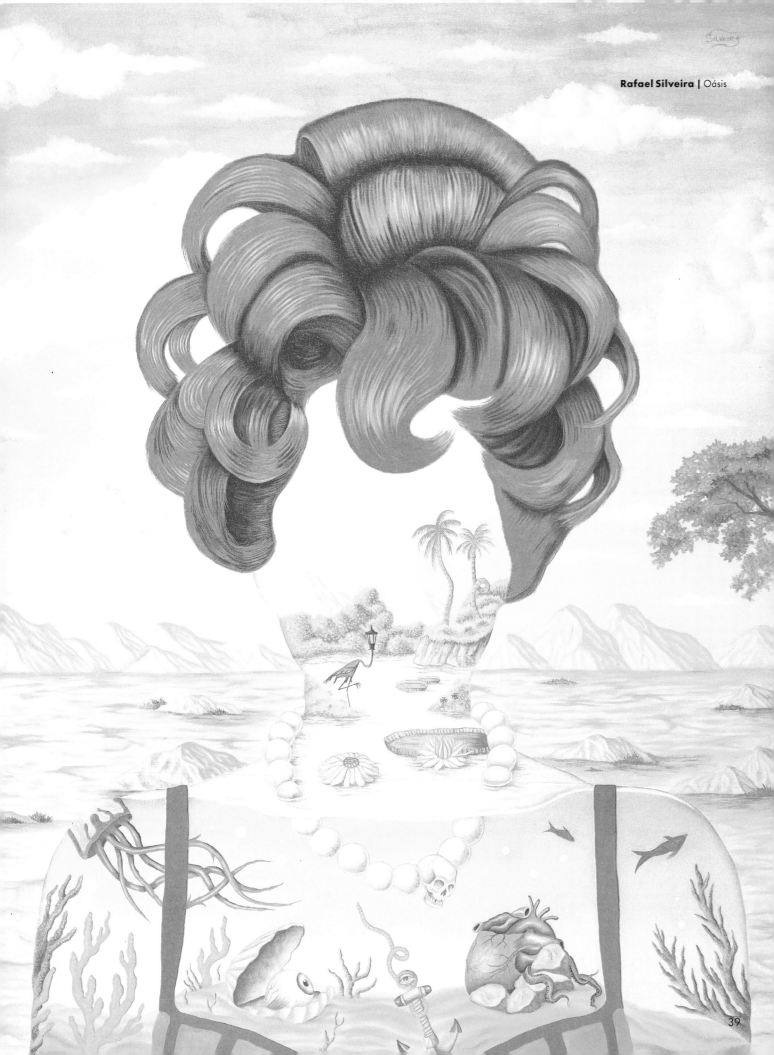

Irina Sizikova
sizikovaiv@gmail.com

Dear Dr. Bernard Chervet and dear colleagues!

I am a psychoanalyst from Moscow. Moscow has become empty. I've never seen Moscow in this condition. We now live in uncertainty and isolation.

I do not have experience with remote analysis. As of this week, I have needed to reorganize my entire working schedule. It is hard for some patients and for me.

As the government strengthens quarantine measures, people realize the "unknown" danger: the danger of disease and death. In the last two weeks of sessions, nobody has spoken about their hopes and aspirations, only about their fear of death, about their health and the health of their loved ones.

More and more, I read these posts, but most often I reread the post of Dr. Bernard Chervet:

> At first, the traumatic neurosis is triggered—and we need more time, latent time, to re-find the logics of the "après-coup" (or the deferred effect). For the moment, everything we are doing is inscribed in the logic of the first traumatic time.

> The elusive viral disease is a great source of threat and negative irrational transference. The belief in the power of super-mother super-father is broken; the demand that the government, the doctors and scientists, and psychoanalysis offer all-powerful solutions comes with great anger and sadness and reproaches about the abandonment, the distress...

So, we cannot have a debate on remote analysis in this context. Remote analysis is imposed on us. Everyone is concerned with their health and that of those close to them. And the logics of "traumatic neurosis" dominate.

Many thanks,
Irina Sizikova

Дорогой доктор Bernard Chervet и дорогие коллеги!

Я психоаналитик из Москвы. Москва становится пустой и я никогда не видела Москву в таком состоянии. Мы начинаем жить в большой неопределенности и изоляции.

У меня нет опыта удаленного анализа для пациентов. С начала этой недели будет необходимо реорганизовать все расписание сеансов. Это не просто для некоторых пациентов и для меня.

С ужесточением мер, которые принимает правительство, осознание угрозы «неизвестного», угрозы болезни и смерти нарастает в обществе. И речь не идет последние 2 недели о мечтах, речь идет на сеансах о страхе смерти и своем здоровье и здоровье близких людей.

Все чаще я читаю посты всех вас, но чаще всего пост доктора Bernard Chervet:

> «...Травматический невроз сейчас на первом плане; нам нужно будет дополнительное время, чтобы переосмыслить логику "après coup". Неуловимый вирус является огромным источником угрозы и негативного иррационального переноса. Вера в супер-отца и супер-мать рушится; требования, которые предъявляет правительство, и условия психоанализа сталкиваются с сильным гневом, печалью и укорами.... Поэтому мы не можем обсуждать, что лучше – удаленный анализ или личное присутствие. Все беспокоятся за свое здоровье. И доминирует «травматический невроз».

Спасибо всем вам, спасибо IPA!

Ирина Сизикова

Photo by Kyle Cut Media

Ronald Davies
rnsdavies@gmail.com

Alice Lowe Shaw
aliceshaw4@gmail.com

Dear Ronald,

What you have described of the current conditions and anticipated devastation in the poorer communities of your region is heartbreaking and a harsh reminder to hold in our minds, and consider for actions, the poorest and/or most marginalized among us.

As well, I am heartened by the open, thoughtful, compassionate sharings among this psychoanalytic body.

Wishing safety, health, recovery for all!

Alice Lowe Shaw

Dear All,

I work privately and in our public health system—where most of our patients come from severely impoverished backgrounds—where therapy can be framed as being psychoanalytically informed.

Reading all these offerings, I extend my deepest feelings of empathy to all of you who are suffering under these extreme conditions of isolation, deprivation, and death. Simultaneously, we are having heightened anxiety and fear for our patients in our public health system who have to sit in public waiting areas, where stringent preventative measures have yet to be put in place and where the isolation—which I want to scream for, both for them and myself—most likely is not possible given their impoverished living conditions and which may be a barrier we are not able to put in place timeously—or maybe not at all.

Our fears grow that this virus will soon enter our poorer communities, where there are also high rates of HIV/TB/diabetes infection and where the devastation may be incalculable.

It leaves me feeling afraid, angry, and helpless.

Warm regards,

Ronald Davies

6.20.26
Philadelphia, Pennsylvania, USA

Harvey Schwartz
harveySchwartz@comcast.net

Colleagues,

I'm noticing that my relationship to the experience of self-disclosure is being affected by this health crisis we are all in the midst of.

With some, sharing aspects of our common fears and uncertainties deepens the intimacy between us and allows for the emergence of affects, fantasies, and memories that further our work.

With others, those who experience any boundary as a narcissistic rejection, they unknowingly use the commonality of this circumstance to subvert a separateness that would allow for the emergence of frightening desire and memory.

Are others noticing their relationship to self-disclosure being affected?

Harvey Schwartz

6.20.27
Rio de Janeiro, Brazil

Basel, Switzerland

Laura Ferreira
lauzita@gmail.com

Joachim Küchenhoff
www.praxis-kuechenhoff.ch

Photo by Cerqueira

Hi, everybody.

Thanks for this space! I hope you're doing well with all the restrictions. I have two thoughts: First, we are dealing with the fear of death, this fear of annihilation, which is experienced differently for each of us and must be especially mobilizing for those who are in the high-risk group. Generally, for the older generation, technology is also part of the unknown. The isolation, the separation, brings this annihilation feeling. On the other hand, or on another level, we're living an experience which touches all of humanity at the same time. This proximity may bring some hope. I think it is important to verbalize it somehow, within the language of each analytic couple, and receive/hold/welcome (I don't have the word in English) those feelings to build or rebuild the bond in another register (which will bring in previous connections, of course). I have been thinking we have to work on this linkage.

Best wishes for you all. Let's stay connected,

Laura Ferreira

Dear Laura,

Thanks for your contribution! You are right: the crisis touches us all, so we realize that we—the analysand and me—are "sitting in the same boat," as a German saying goes. This fact engenders solidarity, and the shared helplessness provides, in my feeling, an altered common ground.

I try to understand the change in countertransference feelings and my interpretations.

I still work in my office with some patients; this is still possible in Switzerland, although the number of cases is high here. I was asked by some patients to keep the setting unchanged. What does that do to my countertransference? Intertwined with the feelings of solidarity and a heightened empathy mentioned above, there sometimes creeps in an idea whether the patient is a danger to me physically.

We can only register these ambivalent factors shaping the countertransference in an unusual way.

Warm regards,

Joachim Küchenhoff

6.20.28
April 2, 2020
Bilbao, Spain

Cristina Escudero
escuderoreyzabal@gmail.com

Dear Colleagues,

Thank you for the valuable ideas you are sharing in this space. I appreciate it so much. It gives me a lot of support to do my job. Thank you for the generosity and time that you are taking now in sharing your experiences.

In this post, I want to limit my ideas to the topic of technologies and treatment. Two weeks ago, I found myself in a very different and new scene. As I have had no experience in remote treatment, I have tried to do my best to maintain a psychoanalytical frame as much as possible. Initially, I considered that I could work well with patients on the couch because they do not see the analyst, so I shared with Marilia Aisenstein my opinion that the phone is her best choice. She suggested patients stay, if possible, in the same room for their sessions. I also suggested to them that they find a couch and lie down.

Patients on the couch are reporting that they feel quite comfortable working on the phone. It would be a different matter to hold this situation as a standard practice. Nothing is comparable to seeing and feeling our patients nor to being seen and felt by them.

Nevertheless, this new situation has changed my point of view about remote treatment in a way.

Perhaps we could maintain some sessions on the phone and some in person once we know each other. Perhaps we can change our frame. It is something I would like to reflect upon as here, in Spain, we did not practice that way so often.

I would like to share with you some of my personal considerations, among others, about this particular question:

- A session is not only the time that a patient dedicates to the analytic work itself but also the close time dedicated during the pre-session and post-session. I think that pre- and post-time gives the patient an opportunity to experience diverse kinds of sensations, ideas, and concepts. That pre- and post-time is important for the session to be prosperous.

- The pre- and post-time that our patients dedicate to themselves is as important as the session itself. I wonder how much time is dedicated to the encounter with oneself in the remote psychoanalysis setting.

- The unconscious system is always working, but it is closer to consciousness when patients meet their analyst physically. The mind does not elaborate the same when it is deprived of physical sensations.

- Transference material can be more easily brought to consciousness when a patient walks to our place and then later walks from our place. The effort (pleasant, unpleasant, and other) a patient makes is also a matter of analysis.

- The immediacy of the phone call can interrupt the outcome of that kind of material, and on the other hand, it could transform the session into an isolated thing in the daily routine. I work, I eat, I have the session, I take care of my children in a continuum with less psychological and psychoanalytical value.

For patients that are not on the couch, my internal situation is different. This face-to-face position is a forced posture. I try not to look at the camera all the time, as I do not look at my patients all the time in a real situation. Screen treatment can be very intrusive. The kind of contact we have does not include body language. The screen is very limited in terms of the visual field that provides.

I would very much like to hear the experiences and ideas from others who are working with this system.

I hope this painful situation will not last very long, and I also hope that we will reflect on what is happening to human nature—to human psyche.

Kind regards,

Cristina Escudero

6.20.29
March 14, 2020
Pittsburgh, Pennsylvania, USA

William F. Cornell
wfcornell@gmail.com

I am heartened that we have this shared space for the days and weeks ahead.

Photo by Vidar Nordli-Mathisen

I have been at my office for four days now and have worked with the majority of my clients by phone or Skype, although a significant number have chosen in-person sessions. We have modified our office setting to make this as safe as possible. I feel somewhat fortunate in that part of my practice for some time now has been on the phone or Skype, so the shock of working "remotely" is softened somewhat. I can well appreciate the adjustments that many have described in their postings here.

Have we been working as usual? Hardly. Session after session is drenched in concern for loved ones, powerlessness, anxiety, and/or paranoid anxieties. I have often felt invaded by the force of these anxieties. We are each and all, as therapists and analysts, faced with the rather daunting task of managing our own anxieties (and in my case, fury) while still being able to listen and engage with the ways in which this chaos and uncertainty impacts each of our patients—and every one will be different. I am exhausted. I am not looking forward to the weeks ahead. But I think these are times (which seem to be occurring with increasing frequency and violence) to be both human beings with our patients and to still maintain the unique and essential reflective distance that grants the space and psychic freedom to each patient to feel and articulate the particular impact of this disruption and vulnerability. This can be a daunting therapeutic challenge. I am most painfully aware of the additional terror for my patients who live in isolation. This I find nearly unbearable.

I have been reminded of two of my patients who during the week of 9/11 saw no need to spend any of their time talking about what happened in the attacks, one of whom said, "That happened in New York; doesn't have anything to do with me," while the other said, "People die all the time. Does it matter how or when?" Each went on with their usual concerns for their sessions. This was not an easy space to hold, a space from which meaning could gradually emerge. I have felt this challenge more than once this week.

William F. Cornell

Photo by Nathan Dumlao

Photo by Zhuoqian Yang

March 28, 2020

This afternoon, I was seated at my desk when my phone rang, and it was an unfamiliar voice. He introduced himself as a physician at an ICU. A client of mine, a woman with whom I have worked for many years, had been suffering from an extremely rare form of cancer. It had been less than a month since her diagnosis, and now she was dying. As Pittsburgh is in total lockdown, no one is allowed to visit patients in hospitals. I had been talking by phone with her every day. She knew she was dying. Her siblings, torn apart by trauma, violence, and paranoia, were spread all over the country. The doctor said that the nurses knew I had been talking with her every day and she had asked for me. "Can you get here within the hour?" he asked. Yes, but the hospital is closed to visitors. "We don't want her to die alone. We'll get you in" was his reply. When I arrived, she was conscious, enormously relieved to see me. I was masked and gloved. The doctor said, "Take off your gloves so she can feel your hands." I held her hands, and we talked together for an hour as she struggled to hold on to consciousness. She agreed that she was done fighting. Life support was removed, and I sat with her as her life faded away. Since getting home, I've been writing on her behalf, in her voice, to her siblings.

I know I am not alone in being thrown into new ways of being with both clients and colleagues. I can only hope we come through this with our professional identities changed.

As I have read the many reflections of our community as we struggle to work under extraordinary circumstances, I have felt the resonances of so many as we have found these unexpected times of frankness and intimacy. We have much to learn. It will take very long time to absorb the implications of these times.

William F. Cornell

April 8, 2020

I am a somatic psychotherapist—the questions and realities of embodiment do indeed come to the forefront. I think the term "working remotely" is far more accurate in capturing experiential reality than "working virtually."

We are, in fact, working remotely. We are not in the same room; we are not in one another's physical presence; and we are deprived of the wealth of sensate, emotional, and nonverbal communications that silently inform, enrich, and enliven our sessions (with a huge nod to Wilma Bucci's accounting of the place of subsymbolic experience in the psychotherapeutic process). I hear (and myself experience) over and over again the fatigue, exhaustion people experience working the "virtual" realms all day long. It has given me new insights into the anxieties and disconnections my younger clients experience when they spend so much time with the misnamed "social" media. The screens create an illusion of contact. The screens dominate our immediate experience with two-dimensional visual and vocal data. Our receptive tools and capacities are seriously diminished, and I think we are constantly consciously, and unconsciously, trying to fill in the experiential gaps in our contact.

I often hear weary versions of "It's better than nothing." But from a somatic perspective, it is the areas of "nothing" that need to be acknowledged. I have found it essential, as these days of remote sessions go on and on, to not pretend that this is good enough, better than nothing. I am finding it essential to acknowledge and inquire about the experiences of absence, what is missing. This is an acknowledgment of elements of our lived realities as we cannot be in close or physical contact with those with whom we are working, with those we love who are now held at a distance. The experience of loss, anxiety, and grief in our sessions is a core aspect of working somatically.

I wrote recently in this forum about my being invited by an ICU doctor to sit with a client of mine who was dying. I was allowed despite the "no visitors" rule. I arrived masked and gloved. The doctor told me to take off my gloves because she needed to feel my skin. He and the nurses knew. We held hands; we spoke; we felt each other. This could not have been done "virtually." As the medical interventions were turned off and her consciousness waned, she could no longer speak, her eyes closed, but she was still there in her hand. I knew, I felt, her life had ended when her hand left mine.

William F. Cornell

6.20.30
May 2, 2020
New York, New York, USA

Michael Diamond
diamond@missouri.edu

ROOM 6.20 | A Sketchbook for Analytic *Action*

The president stubbornly and arrogantly persists in directing his own personal reality show, which in fact exposes an ongoing assault on reality itself and on the public's intelligence. Our protests and resistance often situated in the public squares and streets of American cities, large and small, have been taken away by this pandemic and the essential necessity of "social distancing" and staying home. Our lives are at stake on two fronts: COVID-19 and Trumpian authoritarianism. We must not allow the president's personal insecurities, narcissistic injuries, greed, and envy to force a premature end to physical distancing and a hasty reopening of the economy; if allowed to do so, it will be deadly. Perhaps as importantly, to stand with concern for democracy and for individual dignity, we must find a way to claim virtual space and actual agency amid these profound horrors.

Michael Diamond

6.20.31
Bethesda, Maryland, USA

Jeneva Stone
jenevastone@gmail.com

Sunlight Is the Best Disinfectant

could you bring the light
"inside the body"?

*(how may I
find the Light
in the midst of)*

supposing we hit
the body
with a tremendous—

*(darkness
of my heart,
which is so
great)*

whether it's
ultraviolet or just
very powerful light—

supposing
you brought
the light

*(by its discovering
and warring
against
the darkness)*

inside the body

through the skin or
some other way

*(both the open
and secret
iniquity of
the corrupt Heart)*

disinfectant
knocks it out
in a minute

one minute

can we do
something
like that
by injection
or almost a cleaning?

*(secret misgivings
that all
is not well)*

it does
a tremendous number
on the lungs

*(but there may
be a flaw
in the covering)*

*—A found poem
from Trump's 4/23/20 press conference,
and a passage (1681)
from the Quaker Isaac Penington
on recognizing Quakerism's "inner light."*

Photo by Mark Stoop

Matt Milligan West Village, Manhattan, New York, USA

Clément Falize Bordeaux, France

Calle Pipila 459, El Retiro, 44280 Guadalajara, Jalisco, Mexico.

6.20.32
March 19, 2020. 6:55 p.m.
Guadalajara, Mexico

Carmen Cuenca Zavala
mc.cuenca@hotmail.com

ROOM 6.20 | A Sketchbook for Analytic *Action*

Kind regards,

I have been reading most of the emails I can from all countries, and it helps me to feel accompanied in difficult moments, as well as it helps me to think about and to elaborate upon an experience that perhaps is overcoming us and is totally new.

One of my greatest anguishes has been the lack of response from the president of my country and others in positions of power. It is outrageous. It is difficult to believe in health authorities, and in the face of this lack of reliability, I have to resort to the WHO website, talk to colleagues who are doctors, and listen to my own criteria.

This week, I still attended my consultation in the presence of all the measures of distance and hygiene, and I listened to the anxieties generated by the situation in each patient and those close to them. Some patients have already asked to stop because they cannot or do not feel comfortable with the use of Skype, and others wish to stop because their income is altered. This raised a question in my mind: Do we take a break in the treatment, or do I actively propose an alternative?

I opted to tell patients who are going to have a 50 percent cut in their salary to come to their appointments, and here we would figure out together what to do with the situation, offering to reduce the fee or payment within a few months or even for the sessions over the next four weeks. I have suggested that the patients might propose a plan we can agree to together.

Yesterday afternoon, a young patient entered the session, saying, "Things are very different." She talked about the suspension of her work and not knowing if she would receive her salary as well as about her confinement in the house. I thought about the changes that there would be in the treatment, about the changes in her internal emotional state. I also thought that she surely found me changed as her analyst; I couldn't find a way to get past the manifest discourse through an interpretation because all her realistic concerns caught me connecting with my own concerns. She spoke about her parents being older and at risk, and at that point, I felt "infected." I began to think about my own older parents and health problems, and I couldn't lend my mind to the session with the patient. At that point, I was worrying about my own parents being left helpless. Finally, I don't know how, I recovered and I realized that the patient was talking a lot and quickly to avoid touching feelings that overwhelmed her. She was afraid to open up more fully since our next session will be online and might not provide the same support.

I am presented with many questions, both as a person and as an analyst. Hearing from other analysts, reading shared experiences, is helping me have a little bit of calm to attend my patients. I think that in these moments, solidarity, flexibility, and humanity are important. The experience of analysis and deep human encounter provides an internal framework for us both in critical and noncritical moments.

Carmen Cuenca Zavala

Saludos afectuosos,

Gracias a la IPA por generar este espacio y a los amigos y colegas por compartir. Soy Carmen Cuenca, analista miembro de Asociación psicoanalítica de Guadalajara. México. He estado leyendo la mayor parte de correos que puedo de todos los países y me ayuda a sentirme acompañada en momentos difíciles, así como a pensar, elaborar una experiencia que quizá nos sobrepasa y es totalmente nueva.

Una de mis mayores angustias ha sido la falta de respuesta del presidente de mi país o bien una postura que indigna. Resulta difícil creer en autoridades sanitarias y ante esa ausencia de confiabilidad me queda recurrir a la página de la OMS, dialogar con colegas que son médicos y hacer caso a mi propio criterio.

Esta semana aún atendí en mi consulta en presencia con todas las medidas de distancia e higiene y escuchando las ansiedades generadas por la situación en cada paciente y sus personas cercanas. Algunos pacientes ya han solicitado suspender porque no pueden o no se sienten cómodos con el uso de Skype, y otros debido a que sus ingresos económicos se ven alterados. Esto me planteó una pregunta: ¿hacemos una pausa en el tratamiento o les propongo activamente alguna alternativa?

Opté por contestar a los pacientes que van a tener un recorte del 50% en su sueldo, que vinieran a su cita y aquí pensáramos juntos que hacer con la situación —ofreciendo reducir la cuota o el pago dentro de unos meses— de las sesiones de las próximas 4 semanas, y que el paciente me propusiera algún acuerdo.

Ayer por la tarde una paciente jóven entra a la sesión diciendo: "las cosas están muy cambiadas." Habla de la suspensión de sus labores, y no sabe si recibirá sueldo, del encierro en la casa. Yo pienso en los cambios que habrá en el tratamiento, de los cambios en su estado emocional interno, pienso también que seguramente me encuentra a mi como analista, cambiada. No encuentro la manera de pasar del discurso manifiesto a través de una interpretación, porque todas sus preocupaciones "realistas" me atrapan conectando con mis propias preocupaciones. Habla de que sus padres son mayores y están en riesgo, y en ese punto me siento "contagiada", mi cabeza se va a pensar en mis propios padres mayores y con problemas de salud y no puedo prestar mi mente a la sesión con la paciente porque me preocupo por mis propios padres (¿quedarme desamparada?). Finalmente, no sé bien cómo me recupero. Me doy cuenta que la paciente habla mucho y rápido para no tocar sentimientos que la desbordan y teme abrir, puesto que la siguiente sesión será online y podría no brindarle el mismo soporte.

Se me presentan muchas preguntas, como persona y como analista. Y este foro me está permitiendo pensar y tomar algunas decisiones. Al leer sus experiencias compartidas, logro tener un poco de calma para atender a mis pacientes y pienso que en estos momentos es importante la solidaridad, la flexibilidad y la humanidad.

El encuadre interno lo proporciona la experiencia de análisis y de encuentro humano profundo que uno ha tenido en otros momentos críticos y no críticos.

Carmen Cuenca Zavala

6.20.34
March 9, 2020
Buenos Aires, Argentina

Juan Pinetta
licjuanpinetta@gmail.com

Translation by Mafe Izaguirre

It is very interesting how this conversation is holding us all together, for in this state of affairs, our sense of safety is taxed to the limit. Even children who are the age of my daughter are dying. The situation is worrying. So I wonder: What remains of the thinking apparatus in times of catastrophe when we must make catastrophic changes?

Economics remains a very strong concern among analysts and candidates. There are complications making the change to treat patients over Skype. On one hand, we explain to patients how this will allow us to maintain analysis without worrying whether one will infect the other, but there are other concerns that emerge related to tolerating the change—even institutionally. One of my main concerns in these times are certain institutional resistances that restrain the creative impulse of some colleagues and may impact the survival of these institutions. We need to find a way to deal with these intergenerational fears.

We are also addressing how the heads of mental health services are denying the reality we are living in by forcing the psychologist and psychiatrist workers to attend sessions in person. While there is an ease that technology offers, we are all observing how online therapy is much more exhausting than face-to-face therapy. The question of excess stimuli is the order of the day. There is not enough time to process all of these stimuli. Anyway, these are some of my thoughts…

Juan Pinetta

Muy interesante este intercambio que nos sostiene a todos. En particular por este estado de cosas donde la seguridad de la vida está jaqueda al límite. No se salvan ni niños de edad de mi hija, que también fallecen. Así que el estado de cosas es preocupante. Insisto en qué nos queda del aparato de pensar, sobre todo en momentos de catástrofe donde debemos hacer cambios catastróficos. Una de las preocupaciones, aparte de ir pasando a los pacientes a Skype explicándoles que así podemos mantener el aparato de pensar analíticamente sin el "ruido" a que uno de los dos esté contagiado, es el económico. En muchos grupos mixtos de candidatos y analistas la económica es una preocupación muy fuerte. También hay otras, como la tolerancia a los cambios. En estos tiempos pareciera verse ciertas resistencias institucionales que frenan el impulso creativo de algunos colegas que son aportes a las instituciones, ya que eso puede ser visto como una pérdida de terreno frente a aquellos que manejan tecnologías fuera del setting histórico, presencial. Esto para mí es una gran preocupación. En realidad, no le es para mí, sino para la supervivencia de las instituciones. Hay que ver cómo se lidia con estos temores intergeneracionales.

Por otro lado, con varios colegas, hemos visto cómo jefes de servicios de salud mental obligan a concurrir a los trabajadores psicólogos y psiquiatras negando la realidad (esto me llega de colegas psi que conozco, muy cercanos). Además, como contrapartida a la supuesta facilitación de las tecnologías, observamos cómo la terapia online resulta mucho más agotadora que la presencial. Así que la cuestión de los excesos de estímulos están a la orden del día, y no hubo tiempo de procesarlos todos aún, *burnout* mediante.

En fin… algunas líneas,

Juan Pinetta

Pink Moon. Dye, pigment, and wind on canvas. 10 by 12 feet. 2020. | Susan Luss at Pier 1, Hudson River Park. 13 March 2020. | Photo credit: Stephen Sholl

Visit Susan Luss Gallery | http://www.analytic-room.com/art/in-the-time-of-now-susan-luss/

Bird Song. Dye, rain, and earth on canvas. 12 by 18 feet. 2020. Susan Luss, en plein air intervention. Sheep Meadow, Central Park. 8 May 2020. Video film still: Susan Luss

Dragonfly. Dye and grate on canvas. 12 by 18 feet. Times Square, New York. 2020. Susan Luss, en plein air intervention. Times Square, New York. 31 May 2020. Video film still: Susan Luss

or scan this code with your smartphone camera

6.20.35
April 15, 2020
Jerusalem, Israel

Yehuda Fraenkel
dr.fraenkel@mail.huji.ac.il

The magnitude of emotional load together with ethical and clinical questions puts us in a total "terra incognita" state. I think that the need for coherence in external chaos is indeed universal, yet to us are both a demand and praxis of psychoanalytic practice engaging intrapsychic chaos.

When external and internal meet in loss of coherence—the inability to foresee, plan, and manage the near and far future—indeed, trauma is the exo-endogenous state of going on being.

From reading what is experienced around the globe, it may be hypothesized that our mutual task is to hold the emotional human existence within new therapeutic boundaries constructed by the ethical principles of psychoanalytic theory and practice.

I suggest that to meet or not to meet, to treat by new methods or not to treat, to reach out to suffering communities and burned-out health care professionals, should all be negotiated within the theoretical and ethical matrix of each and every one of us.

We will come up with divergent and even conflictual answers that reflect the diversity in psychoanalysis around the globe. Although we are part of the same profession, diversity does not mean chaos; rather, it signifies freedom to think and implement within analytic boundaries.

For instance, seeing patients in the room and on the couch: some told me it is crossing the line because it is exposing oneself to life-threatening danger. Others feel that analytic care is also about emotional and physical risk to the therapist, as much as MDs are risking themselves.

I suggest the answer is not organizational yea or nay, but rather an intimate cultural and moral dilemma that has to be answered separately by every therapist—and maybe time and again for every patient.

Yehuda Fraenkel

Photo by Benjamin Grull

Photo by Dove Herring

The streets are not themselves today:
Silence leaves them cold
They long for the dance of leathered feet
And the gossip and chatter of old.

Where has the children's screaming gone,
The skirmish the battle the play?
The schoolyards are aching for childhood sounds:
What broomstick has swept them away?

The sirens keep piercing the eardrums.
(The dead cannot scream for themselves.)
Fear turns into panic and hoarding:
You can't find any food on the shelves.

In the evenings at seven a chorus is born
Of clapping and yelping and roar
Alleluias pour out of the opened windows
As praises for the brave rise and soar.

All flesh is as grass said a prophet of old
As the dead fall like rain in the fields.
Will it not ever end, never end asks the swallow:
Is there no hope that suffering yields?

The streets are not themselves at all:
They sense that something's wrong;
The truth has hidden its face in shame
As hypocrisy sings its old song.

But the brave can never be silenced
No matter what power has to say.
The heart is a thoroughbred hunter,
And love's only a heartbeat away.

Photo by Alec Favale

Julia Roy-Stäblein
juliaroy242@gmail.com

6.20.37
March 17, 2020
Paris, France

March 18, 2020
Paris, France

Gertraud Schlesinger-Kipp
gertraud.schlesinger-kipp@dpv-mail.de

March 18, 2020
Kassel, Germany

Dear colleagues,

I'm a candidate in Paris, and it is so great to hear all of you. Weirdly, this makes us, virtually, connect more. Why are crises necessary to create the motivation of gathering and coming together as a community?

For me, it's not so easy to be a psychoanalyst learner and to already, so early, be faced with such massive changes in the normal working rules. After the attacks, psychoanalysis has had to endure. On the other hand, they follow the changes we, the new generation of psychoanalysts, are already incarnating. I feel, in a certain way, confident enough also. Psychoanalysis builds in us such a nice and solid house. It is this house that protects me against these hurricanes and the force of our network and common will for our patients.

I chose the phone, like many colleagues here. There's something that I find very fake on video, and too exciting, with the exhibitionism trend and internet, such as YouTube, etc., has put into images and videos.

I prefer dealing with the reality of the physical separation. I am more present vocally to deal with the silence that, indeed, can be very cruel. Also, the session are only 30 minutes. So this period of therapy is going to be special. I can already see it brings very specific, but also extremely core, points of my patients' problems. But it's so condensed and quick that it's not easy to treat and answer that very precious and hot material.

It's a lot to think about and it's not easy to think when we're trapped in a traumatic reality, on the same level as our patients.

I'll continue reading these exchanges. They are really helpful.

Many thanks, dear colleagues.

And to make a little joke as I am a fan of *Star Wars*: May the force be with you!

All the best,

Julia Roy-Stäblein

P.S. Sorry, I might have made mistakes with the English. I hope it is still understandable though!

Dear Julia, you are writing so beautifully that I would like to answer you personally. I think that for young analysts, it might be even easier to adapt because we, as senior analysts, have gotten used to our rituals for so long that it is even harder to change. On the other hand, we don't have to pass exams anymore, unlike you in training, and feel, therefore, more free. But as a training analyst, I am always also learning from my supervisees, so I am also learning in this crisis.

Best,
Gertraud Schlesinger-Kipp

Dear Gertraud,

Thank you so much for this reassuring answer. It's true that it's easier for new psychoanalysts to adapt to these differences. But it's tricky. We can fear getting too far into transgressing the limits of the appropriate shape of psychoanalysis, and not being good psychoanalysts anymore.

What you say shows that the best way to evolve is to continue learning how to give the best to our patients, while, at the same time, making sure we're not falling into a terrible trap of transgressing the appropriate rules for our patients' best benefits. And sharing with colleagues our various experiences is the best way of doing this.

I hope the situation in Germany is not too hard and wish you all the best.

Julia Roy-Stäblein

Found Quarantine Ode on FB

Remember when
we all thought
it was sad

that a medieval
cathedral caught
on fire? Ah, what

sweet summer
children we were.

Rosemarie Nassif
romynassif@gmail.com

Dear all,
Thank you for sharing your experience with us.

I am a candidate from the Lebanese association. As you may know, the last six months have been very hectic in Lebanon: first, the revolution movement; then, the economic and financial crisis; now, the COVID-19 pandemic. Lots of losses to deal with.

As analysts, we have been dealing with a great deal of external reality in our practice these past months.

In my opinion, the real challenge is how to stay analysts in these very exceptional circumstances!

Take care,

Rosemarie Nassif

Photo by Mohamad Ossayli

Photo by Nathan Anderson

To all,
Some thoughts

There is much to be disturbed about. We are socially isolated while surrounded by reports of death, risk to life by an invisible assailant, and countless tragedies compounded by mismanagement and blame. We are not sure our hospitals will be available to provide care if we or loved ones need it. Compounding all this is an economic crisis of depth and unclear duration.

There is no question this is an unprecedented crisis for all alive today. There is much tragedy, and there is much uncertainty that we and all who we treat share: Will I or my loved ones succumb? How long will this go on? What will happen to my finances? How else can I help, knowing what is happening on the front lines, and how can I manage feeling helpless? When will we feel safe? What will the world look like when we can once again leave our homes?

This crisis is different from other crises of the past century. We are threatened by an invisible foe, but we do not have to fear being assaulted by individuals who might come into our homes to take our possessions and our lives. We can walk outside. The economic crisis will be followed by rebuilding, and analysts can maintain a means of livelihood. We live in an era of communication unimaginable twenty years ago, allowing us to talk to and see each other despite our separation. And there is the paradox of common experience and a sense of community because of our isolation. And this sense of community extends to the world. There is less external distraction and more time for internal reflection.

I have been most heartened and touched by the determination of those in treatment to persevere in their work, using adaptations that make this possible, and of others who initiate care during this unusual time. I have also been moved by the commitment of parents to ensure that their children's psychological needs are still met while so much else is happening. This is a time and opportunity to support each other and draw upon our knowledge, skill, and humanity to help others draw upon theirs.

Lee Ascherman

Cosimo Schinaia
cosino.schinaia@gmail.com

Dear colleagues and friends,

Some days ago, I received a phone call from a friend of mine who is a doctor of general medicine. He wrote that he appreciated my essay on coronavirus posted on IPA's website but that it is not too useful for him.

The doctors in the hospital and in the medical offices are at risk of falling into a serious burnout, not only because they work too much but mostly because of the anxiety of uncertainty. How long could the epidemic last? How we can resist it? What answers can we give to the anxious patients? How can we survive as physicians in this situation without knowing its duration and its outcome? How can we resist death—not only of our patients but also of our colleagues and nurses? Physicians, according to him, are equipped to give medical responses or provide common sense, but today their common-sense answers are not sufficient.

Anxiety permeates them and their functioning. Sometimes they have to decide who can survive and who has to die because it is impossible to care for all the hospitalized patients at the same time. He was relieved when I suggested to him that we might build online Balint groups led by psychoanalysts. He told me: "Whoever will be able to manage our anxieties could help us to avoid becoming overwhelmed by the panic." I think we can explore the possibility of organizing these online Balint groups, and in this way, we can give room to our social function. Do you think that it is possible that IPA could suggest this possibility in all countries? Best wishes and take care of yourself and your patients.

Cosimo Schinaia

Cari colleghi e amici,

Ho appena ricevuto una lunga e angosciata telefonata da un mio caro amico medico, segretario provinciale della Federazione Italiana dei Medici di Medicina Generale.

Mi ha detto che ha letto e apprezzato il mio saggio sul coronavirus postato sul sito IPA, ma che questo saggio non l'aiuta molto.

I medici, sia quelli ospedalieri che quelli territoriali, sono a grave rischio di logorio psicofisico non solo per i turni massacranti, che pure hanno grande peso, ma soprattutto per l'incertezza che avvolge questi tempi. Quanto durerà l'epidemia? Con quali forze possiamo opporci ad essa? Quali risposte possiamo dare ai pazienti angosciati? Come possiamo sopravvivere emotivamente, anche come medici, a una situazione di cui non conosciamo durata ed esiti?

I medici sono attrezzati per risposte di tipo terapeutico e anche di buon senso, ma oggi il buon senso non basta perché l'angoscia pervade anche loro e la loro operatività.

Gli ho parlato dell'ipotesi di costituire gruppi Balint telematici per lenire la loro sofferenza emotiva e mi ha risposto in termini molto positivi:

"Coloro che hanno più dimestichezza di noi con le angosce, come voi psicoanalisti, potrebbero aiutarci in una situazione che si rivela sempre più catastrofica, evitandoci di essere travolti dal panico".

Ho pensato di rivolgermi a te per proporti la possibilità che l'IPA possa farsi promotrice di un progetto che preveda la possibilità di gruppi Balint telematici con medici ospedalieri e territoriali, condotti da psicoanalisti.

Credo possa essere un modo anche per dare spazio alla nostra funzione sociale. Pensi che questo progetto sia realizzabile?

Abbi cura di te e dei tuoi pazienti.

Cosimo Schinaia

I am simply grateful and profoundly moved by all of your sharing.

Photo by Erik Eastman

As we do the holding for our clients in this time of confinement, accelerated changes, tragic losses, and fear, someone must hold us as well, being a loving partner who offers a hug at the end of day; or we must have a spiritual practice that calms and grounds our breathing or a community like this one, whom I can imagine silently and attentively listening.

It has been a difficult two weeks, with the added sudden learning curve of an online practice.

As an Italian immigrant in Canada, my heart breaks for both my homeland and my adoptive one. I have found myself checking the rising numbers in other countries also, where my clients have ties: Mauritius, England, Philippines, South Korea, Bermuda, New Zealand, etc.

What I am left with from reading your posts and my own self-reflections is a sense of how this shared humanity has, at its most essential level, no borders. There may be a lot of talk about borders, these past few years especially, and even now, in a different context, as symptomatic people may be crossing over a border and putting the people behind it at risk—as if borders could save us from this one.

Behind the protective mask, I see the same grieving eyes in the exhausted Italian doctor, relating perhaps the last words from a critical patient to his family over the phone; in the Chinese student walking alone through surreal emptiness in an otherwise vibrant Hong Kong; in the lost look of the cashier at my local supermarket, who, shaking her head, repeats to almost every customer, "My daughter is a nurse," as if invoking the protection of a collective awareness to shelter her loved one from danger and herself from the potential loss.

Human suffering, grief, hope, joy, fears, pleasure, all of what makes us human finds meaning in the sharing. And I suddenly understand now that what compels me to break my silence at this time is to find holding for my grief, by sharing it; I exist in this. I am grieving and holding hope, like you and with you. Thank you!

May you all keep safe and well,

Stefania Baresic

To ROOM,

The coronavirus pandemic has rocked our world as we knew it, bringing visceral waves of anxiety and fear and unspeakable, unbearable loss in its wake. For many of us, our way of life, our livelihood, our intimacies, and our social connections have been relegated to the phone and the internet—digital lifelines of virtual contact in which the very medium of connection can accentuate the distance, the loneliness.

Existential fear and dread have imploded our waking lives and our sleep. There will likely be no degrees of separation or insulation for any of us from the loss: from deaths distant and close, from reduced incomes and jobs lost, from our ways of life altered, now, and in the foreseeable future in ways we know, at our core, that we cannot fully know.

One young adult patient of mine described a sensation of being "suspended midair," at once fearful of falling yet frozen in time and space, his past and future collapsed into now. For another patient with a traumatic past increasingly managed over years of painstaking psychanalytic work, her now is an inescapable presence forcing itself into a hard-won absence. And for yet another there is a sense of relief that his worst fears about the world's hidden dangers have finally been realized.

I navigate familiar NYC streets, at once known and bizarrely foreign, empty: to exercise and shop, all masked up and hypervigilant of my social distance, walking with a quick step to avoid an invisible attacker. The relentless wails of EMT and police sirens signal warning and portend mourning with no time to spare. Multitasking with my patients' experiences, I toggle emotionally between resolve and resignation, hope and despair, in touch with the fragility of existence I often kept at bay, a necessary illusion of modern life and of professional work. And I try to hold the mind-bending contortion of keeping my distance and reaching out, greeting people who risk making eye contact with a nod or hello or a wave. For we are surely "all in this together," as the saying goes; but truth be told, life in the time of COVID-19 is not the equalizer we imagine—not the pain or the loss or the economic fallout.

The communal outbursts of solidarity each evening to honor the sacrifice of medical, public service, and service industry personnel who work the background to make modern life possible is our daily antidote to despair and isolation here in NYC and around the world. Like an unconscious alarm clock set each evening to 7:00 p.m. sharp, it also is a tribal expression of our interdependent existence as citizens of the planet. Perhaps, too, it is a marker of the growing awareness that this crisis has exposed deep societal fissures of inequity and injustice. And perhaps, a nascent plea and hope for a sea change in humanity.

Joseph A. Cancelmo

Leon Anisfeld: Psychoanalyst, Writer, and Editor
October 4, 1948–March 20, 2020

Leon was born a year after his parents met and married in a Displaced Persons camp in Germany. Leon's father's first wife and their two daughters had been killed, and Leon's mother had lost her infant daughter to starvation. Some decades later, Leon and Arnold Richards would co-author a paper on the psychoanalytic significance of replacement children for the journal *Psychoanalytic Study of the Child*. Leon's sister was born, and when Leon was three, his family moved to an egg farm in southern New Jersey. When Leon was eleven, his father, who had lived through four heart attacks, succumbed to the fifth. Leon and his mother and sister moved to NYC. Leon was lanky and athletic. He loved bicycling, and his serious interests took him in unusual directions. He graduated from City College and received a master's in international relations, planning to pursue a career in diplomacy with a focus on Brazil. Thinking better of the idea, he decided to become a psychotherapist. He completed his doctorate at the Columbia University School of Social Work and did his analytic training at IPTAR, where, along with graduating in 1986, he met his future wife, Janet Fisher. Their daughter, Stephanie, was born on October 4, 1988, and their first grandchild, Liliana, was born on June 11, 2020.

Leon was diagnosed with multiple sclerosis when he was twenty-three years old and lived with the disease for forty-nine years. His membership paper at IPTAR, which was published in *Psychoanalytic Review*, was revolutionary for its time. Leon wrote about the experience of being a disabled analyst and the effect a disabled analyst has on patients. Leon thwarted death again and again, arising, much as he was born, from the ashes. Leon's life, like his work, was creative, brave, and loving. Many of us on ROOM's editorial board knew him only in his last years through his thoughtful and avid contributions to our conversations. At the last editorial meeting Leon attended, he was thrilled to be feeling so well. He sat at the end of the table, where he always sat, and lent voice to how much he valued Daniel Burston's essay on authoritarianism. He died in New York of COVID-19 during the first week of quarantine. We will miss him. ROOM is entering into a new era and will not be the same without him.

If the voice fails to find the happiness of the word, chirp.

scan to listen this audio

or scan this code with your smartphone camera

Manuela Tosti
manuela.tosti@gmail.com

6.20.44
March 19, 2020. 7:54 a.m.
Bolzano, Italy

I feel very blessed about the possibility of hearing your voices coming from all over the world.

This is connection, containment, intimate sharing, and deep support in a harsh and uncertain time.

Thank you all for being there, narrating your stories, your fears and fragilities, and for giving me the chance and the space to share my own.

I'm writing from the northmost part of Italy, locked down in my family town, a one-hour drive from the place where I usually live. My last weeks started with denial and a deep irritation about feeling bombarded with trivial, blown-up, and panic-inducing information.

I wasn't aware of the tsunami rising above us and ready to hit my beloved country with full impact.

I decided to prescribe myself a rigid social media and news diet in order to protect my psychological well-being, communicating my digital retirement even on Facebook. As a longtime world traveler and backpacker confronted with severe illnesses and critical hygienic conditions in minorly developed countries, I found myself shaking my head and glossing over what I felt was media-induced mass hysteria. In my grandiosity, I fiercely relied on the health of my immune system. I classified myself as not belonging to any of the risk groups, not yet informed about the intensity of the contagion risk and the chance that I could be a potential passive, asymptomatic transmitter. I shifted the responsibility to every single one of us, being responsible to guard his own health.

Now, I feel ashamed for this way of thinking, and I feel deeply betrayed by the local media and the government for not giving proper and crucial advice sooner.

From the beginning, I have been cautious, avoiding direct contact with anybody and switching to remote ways of meeting my patients.

A week ago, I developed flulike symptoms, starting with a sore throat, headache, and proceeding with a low rise of temperature, an enormous tiredness, and awkward muscular pain. For three days, I slept up to eighteen hours, waking up regularly through severe nightmares. I felt my body fighting.

I still want to believe it was a normal flu, but I know not everybody develops the full spectrum of symptoms.

I put myself in total physical isolation and contacted my doctor via email, asking to be tested, but my symptoms don't seem to be severe enough.

I guess we don't have enough swabs.

Thank god I already feel much better, but I still don't know if I'm positive and a potential danger for putting others, like my eighty-year-old mother, at life risk. So, as advised, I keep staying physically isolated.

Twice a day, I get food from my family living in the flat next door. They come over to put it in front of my door. This picture looks to me like being in prison, but I'm a lucky prisoner; I get really good Italian food, and my prison is stocked with great books. I have Wi-Fi, a TV, and Netflix.

I'm thinking about moving my quarantine to my main domicile, keeping isolated, but what if a family member gets ill, and I'm not allowed by the government to move and will never see them again?

It feels weird and anguishing.

Watching videos of Italians, even my favorite singers, cheering each other up and sustaining us all with songs from their balconies make my eyes get wet. I need to swallow, and I feel as if my heart would be the softest place on earth.

Seeing pictures of Chinese doctors being flown to Italy to support our health system with planes full of medical equipment, and photographs of the Italian flag proudly shown in several countries of the world fills me up with wonder, emotion, and a deep sense of gratitude.

Never in my life have I felt such a deep sense of global support, of solidarity, and of sharing humanity together! And my eyes get wet again.

The same support and solidarity I want to send out to ALL OF YOU!

I feel deep empathy and sorrow for all the people touched by

Elizabeth Goren
drlizgoren@gmail.com

March 19, 2020. 8:23 a.m.
New York, New York, USA

this tragic epidemic, for the lonesome elderly being quarantined, and for all those who lost or are going to lose a dear one, robbed of the chance to say goodbye due to the risk of infection.

We had 475 deaths just yesterday. The churches of Bergamo are full with coffins arranged in double rows. Funerals are carried out 24/7 in half-hour rhythms, and since yesterday, military trucks bring the bodies to other cities for cremation. This leaves me speechless.

While I was writing this post, a good friend of mine called me. He's tested positive and asked me not to tell anybody. I feel frozen and very vulnerable.

We are in the midst of a real and no longer deniable collective trauma.

In our narratives, we will speak about "before and after the epidemic."

What can we do to implement our agency, to handle this tsunami emotionally and practically, as humans and as therapists?

I think that now we really need to "make sense together," between us and also with our patients, sharing common humanity, vulnerability, and hope, maybe like never before.

Take care and be safe.
With love from Italy,

Manuela Tosti

You are not alone in having our all-too-human grandiosity smashed by being taken down by reality of this enemy. You are surviving, and I am sending a hand out to you, someone who I know only through your picture and willingness to write to us. So far, no one in my family has been taken down by COVID-19, but one of my wonderful patients has, someone who was a caregiver too. But as I write, I await test results for four or more people whose paths cross mine, as they are loved ones of my people, those whom I work closely with here in New York City. Psychoanalysis is not merely a discipline, a therapy, an intellectual, emotional endeavor— it is the language of soul for many of us.

Sending a virtual hug and wishes for full and speedy recovery,

Elizabeth Goren

Elizabeth Trawick
etrawick1@me.com

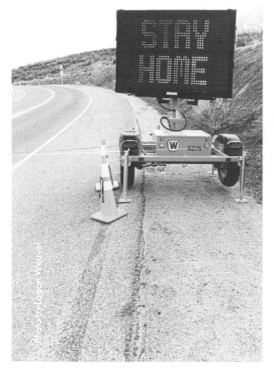

My thinking has been simpler, less developed. Yesterday morning, I did three sessions: one phone, two FaceTime. At the end, I was overwhelmed with emotion, struggling to hold myself together. My last patient had her own version of "I'm not accomplishing anything." I realized that she is working so hard in unrecognized ways: caring for her ninety-four-year-old father when she just remarried a few months ago, needing to social distance from a beloved daughter who is coming to town, having the strength to do this, her own terror and needs for care, etc. The familiar storms that batter us now. I said to her simply that she is doing so much work emotionally that she does not recognize. She was relieved of a piece of her omnipotence, recognizing she can't do it all for everybody. When we ended, I thought, *all this is just so much work*. For me too. And that is the thing—these emotions are constantly with me, requiring constant containment, containing awareness. I can't leave them and yet so much is still unworded.

I live in Alabama. Monday, the reopening begins. I have an email from my massage therapist. I can have a massage wearing a mask, after my temperature is taken and my oxygen level checked. And I use hand sanitizer. All has been cleaned and ultraviolet light shone on everything. This is tempting, but could I breathe deeply and relax with a mask? The nail salon in my condo complex will likely reopen. Oh, I would love a pedicure. Now, a new piece of work. Say no, no, no. Wait. See what happens. Be glad for the socially distanced walks with dogs— though, honestly, I am beginning to hate them and their needs. Sometimes I yell at them, and then know they don't deserve that. Then, I try to hold my hatred. That one is very hard. So much to hate that cannot, it seems, be changed. I live alone except for two dogs and a cat. No one except me has been in my home for two months. I want to cook a dinner for friends and have everyone sit around my table with wine and comfort food. I want to be appreciated for it. I hate that I can't. On and on I could go.

Now, the morning is sunny. My old dog, Sunny, waits for his walk. I go.

Again, thank you, all.

Elizabeth Trawick

Indulging the hope that we'll be returning to psychotherapy and psychoanalysis in person and in office in the not too distant future, I wonder what, if anything, I will take away from this new and enforced remote arrangement. Although by the end of the day, my eyes are dry and achy from staring at the screen, it's also true that the narrowing and intensity of focus seem also to have fostered a heightened concentration and attentiveness. Do I only imagine that I register the shifting expressions of my patients more acutely and record their words and inflections more carefully? I feel grateful to them for continuing to communicate with me, and the external circumstances that we share establish a novel symmetry and bond. Essential freedoms, once taken for granted, are curtailed now: breathing in the air unthinkingly and walking outside; brushing up against other humans and speaking to them without fear. Loss and deprivation heighten perceived value, and the significance of human connection has never felt dearer. And in the special form of relationship created in psychotherapy and psychoanalysis, the perception of the potential and power of attuned listening that lies at the heart of the work seems amplified too. Perhaps some of this raised consciousness and appreciation will be carried into better times.

Dinah Mendes

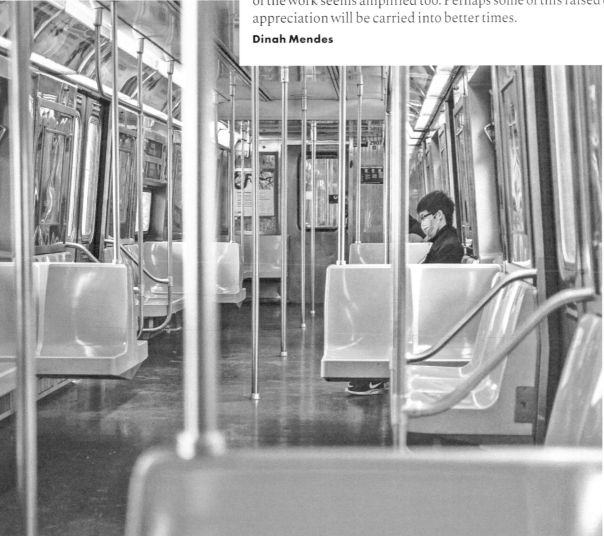

6.20.48
New York, New York, USA

Kate Angus
katea215@gmail.com

The plants are happy

that we stay inside
I tell myself, guilty already

for thinking of how we would flee them.
I do not want to be responsible

for their tender green. We cannot flee
anyway. Who knows if we carry

a virus inside our breath already.
Today I wait to make sure

no one has been in the hallway
and take out the trash, masked

as a mugger, gloved as an assassin.
I read books about the old plagues

in London. I watch online video of a fox
leaping in the snow. Gamboling; cavorting.

When will we again? Last night I imagined
I was dead already or you were and we were in hell

with the other one's body pretending
that we still lived. It's still lonely now when everyone

is lonely. I eat blueberries, each one gnashed
in my teeth like a perfect world.

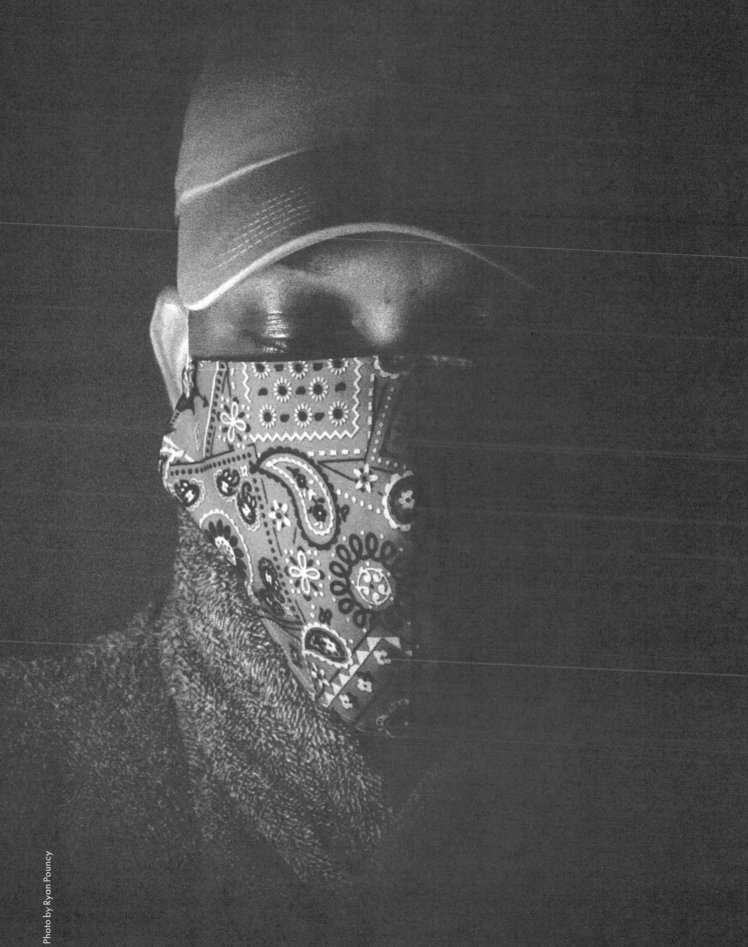

JOIN US!

We are pleased to invite you to

ROOM ROUNDTABLE VIA ZOOM

Join our international ROOM
community as we share thoughts
and feelings in response
to the evolving global situation.
We are facing multiple crises
and dangers but also multiple
opportunities. There is a lot to begin
to try to sort out as old certainties
give way, for better and for worse,
and new possibilities are glimpsed.
It is a remarkable historical
moment. Come and share
how this moment is playing out
in your world or in your thoughts.

Please join and think with us.

To receive the invitation,
please join our mailing list by visiting:

analytic-room/subscribe-now

Facilitated by Richard Grose
and Janet Fisher

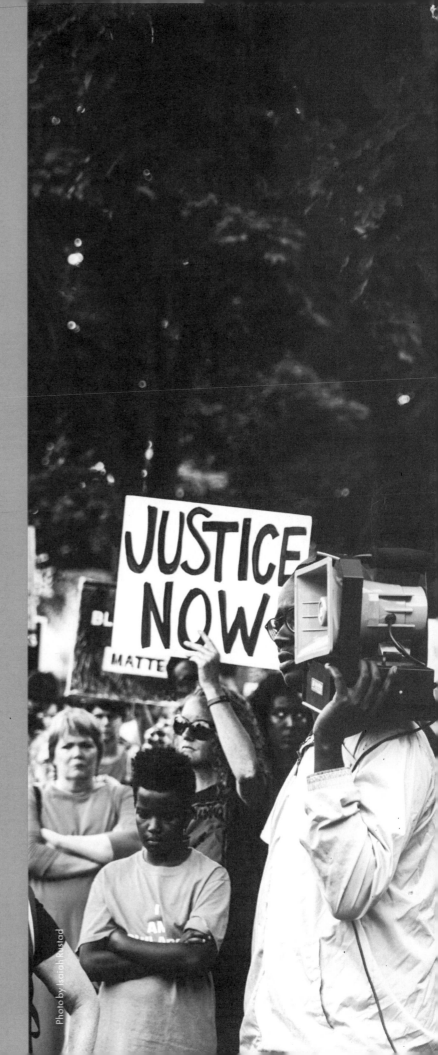

Photo by Isaiah Rustad

SCAN to join our **MAILING LIST**

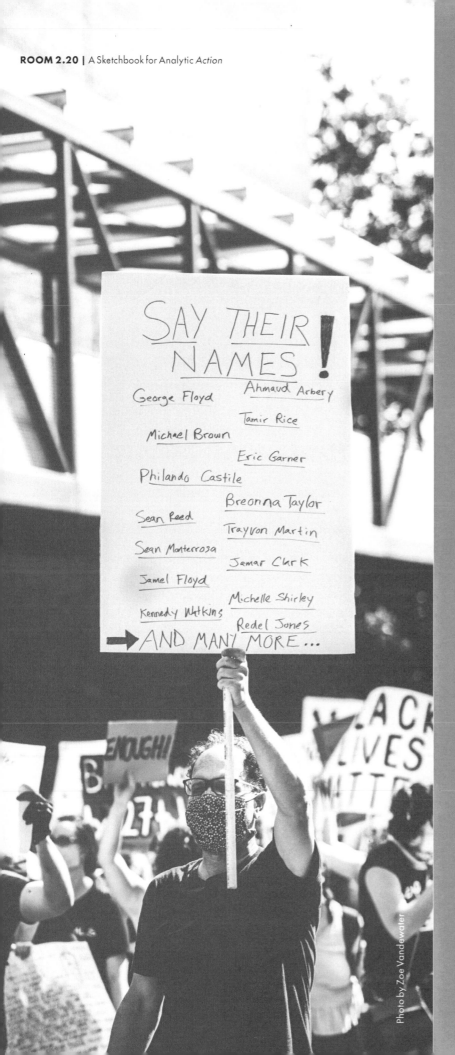

Photo by Zoe Vandewater

WRITE NOW!
OPEN FOR SUBMISSIONS
ROOM 10.20

Essays* | Poems | Fiction | Photographs

We welcome clinical, theoretical, political, and philosophical essays, as well as poetry, stories, artwork, photography, and announcements.

**Length: Max 1500 words*

VIA SUBMITTABLE
analytic-room.submittable.com

or scan this code with your smartphone

SCAN to download past issues

ROOM: A Sketchbook for Analytic *Action* promotes
the dialogue between contributors and readers.
ROOM's first issue was conceived in the immediate wake
of the 2016 US election to be an agent
of community-building and transformation.
Positioned at the interface between the public
and private spheres, ROOM sheds new light
on the effect political reality has on our inner world
and the effect psychic reality has on our politics.

CPSIA information can be obtained
at www.ICGtesting.com
Printed in the USA
LVRC012041020920
664631LV00007B/83